STONE ROBERTS

Paintings and Drawings

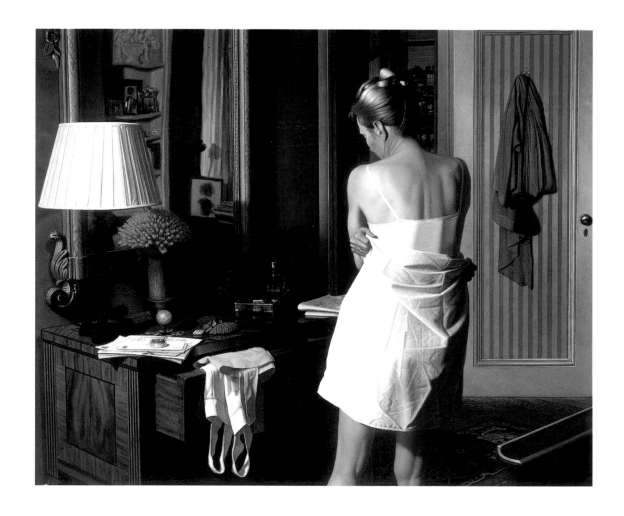

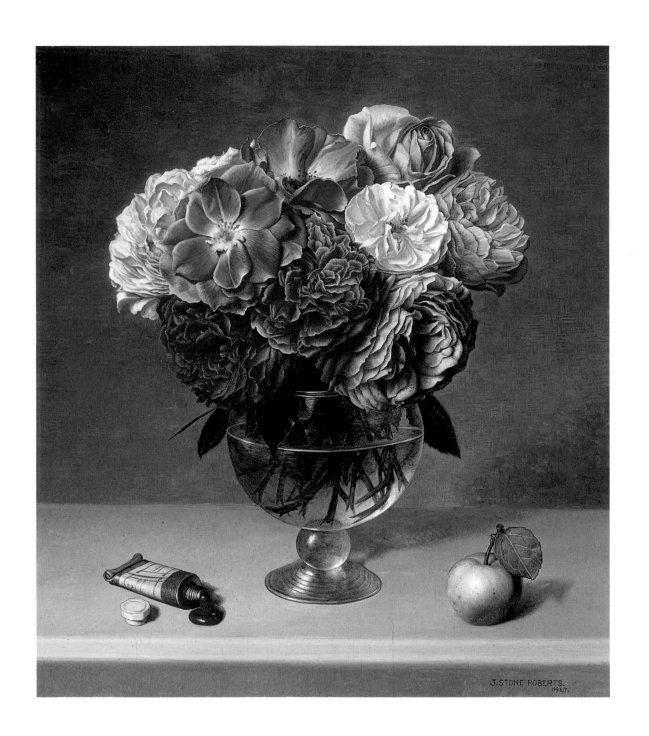

STONE ROBERTS

Paintings and Drawings

Revised Edition

Essay by Charles Michener
Introduction by Verlyn Klinkenborg

Harry N. Abrams, Inc., Publishers

FOR BETSEY

For the 1993 edition:

Editor: Mark Greenberg
Designer: Carol Robson

For the 2001 edition:

Editor: Julia Gaviria
Designer: Carol Robson

Library of Congress Cataloging-in-Publication Data

Roberts, Stone, 1951–
 Stone Roberts : paintings and drawings / essay by Charles Michener ;
 introduction by Verlyn Klinkenborg.–Rev. ed.
 p. cm.
 Originally published: 1993
 Includes bibliographical references.
 ISBN 0–8109–4438–3 (alk. paper)
 1. Roberts, Stone, 1951—Catalogs. 2. Figurative art,
American–Catalogs. I. Michener, Charles. II. Title.

n6537.R5734 A4 2000
759.13–dc21 00–063980

Printed and bound in Japan

Harry N. Abrams, Inc.
100 Fifth Avenue
New York, N.Y. 10011
www.abramsbooks.com

PAGE 1: *INTERIOR, EVENING* (detail)
1997/98
Oil on canvas, 75 x 60 in.
Private collection, Greenwich, Connecticut

PAGE 2: *ROSES, APPLE AND PAINT TUBE*
1996/97
Oil on canvas, 12½ x 11⅛ in.
Private collection, New York

Page 5: *STILL LIFE WITH NIÑOS AND BLACK SAPOTE*
1991
Oil on canvas, 18¼ x 20⅛ in.
Collection Alex S. Jones and Susan E. Tifft

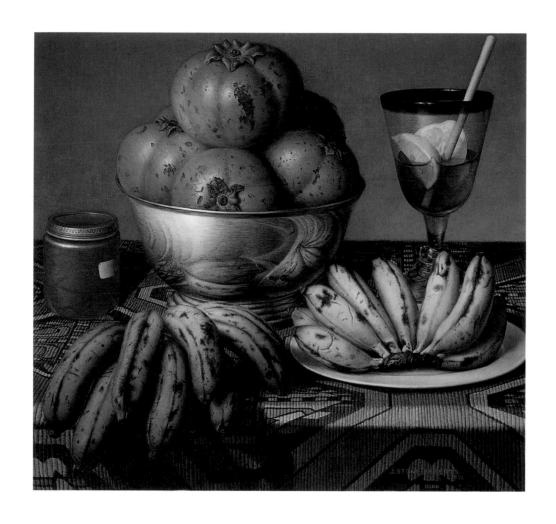

CONTENTS

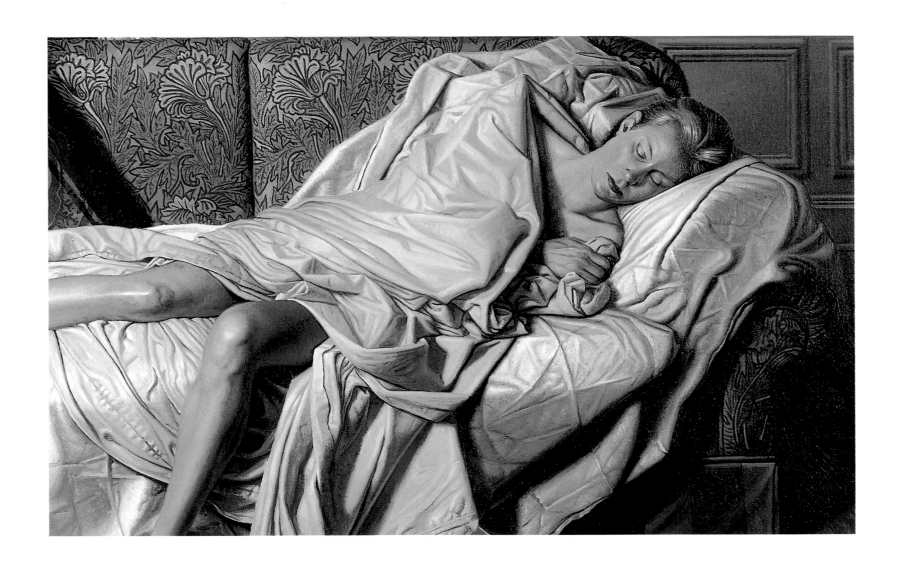

DANAË (detail)
1997
Oil on canvas, 12 x 16 in.
Collection Brooke and John Fowler

STONE ROBERTS

<div align="right">Verlyn Klinkenborg</div>

The woman wrapped in a golden sheet is Danaë. Her father, Acrisius, afraid of a prophecy that Danaë's son would someday kill him, shut his daughter in a brazen tower. But Zeus's lust was not so easily restrained. He descended upon Danaë as a shower of gold where she lay imprisoned. ("Marvelous ankles," Zeus says of Danaë in Robert Fagles's translation of *The Iliad* [14.383].) Thus, she became the mother of an infant son, Perseus, with whom she was cast adrift upon the sea. Zeus's lust is, of course, mutability itself. He is the swan that rapes Leda, the bull that carries Europa out to sea, the eagle, the golden cloud. His erotic force is so overpowering that by his own nature he makes his mortal lovers chaste.

It is this chastity—this transfiguration—that Stone Roberts has caught in his own *Danaë.* Here is no brazen tower but an Upper West Side apartment. Instead of an impregnating cascade of gold, a wealth of divine seed, this Danaë—modeled on the artist's wife, Betsey Roberts—clings to a fabric whose essence is modesty. There is no god hidden within this sheet, nor does a prophecy lurk in the shadows. The painter's allusion to the ancient myth flickers and is superseded by the light of day spilling in from a distant window, by the figural riches of this painting's other regions.

How chastity coexists with what Goethe calls the "opulent corporeality" of the visible world is a question that can be asked of most of Stone Roberts's paintings. By chastity I don't mean the personal virtue of sexual reticence. I mean what might be called a pure light, a clarifying sense of illumination—delicate radiance, tactful effulgence. It is the light in which things appear as they are. For most of us, seeing Roberts's paintings for the first time brings recognition, a naive tallying of the objects that appear within the frame—the frog in the teacup in *Flowers, Frogs and Colchicum,* the smudge of coffee foam in *Breakfast Still Life,* the old-fashioned, oversized cowboy hats in the necktie pattern in *Dressing Table Still Life.* The familiarity of a spool of thread, a key fob, a bottle of Tabasco is an enticement to the viewer, a way of beginning to expose the fundamental strangeness of such visual acuity.

But after a while you realize that what Roberts has painted is not just a startlingly coherent arrangement of dahlias or the high season of peonies in a bowl. What he has also painted is the space within which these objects muster their opulence, their corporeality, their dimensional substance. They stand forth and impinge upon sight. They keep the secret of their hidden surfaces. They project themselves into the roundness of our attention. They hold open the world they occupy. And they remind us of something we are always on the verge of forgetting or taking for granted, which is how the discreteness of objects, their separateness in space, actually unites them in our awareness. These paintings are studies in perception, lessons in what it means to take up habitation in the physical world.

"Still life" is a convenient genre description and an element in the title of many of Roberts's paintings. But it's such a familiar phrase, dating to mid-seventeenth-century Holland, that we lose sight of its inner contradiction, which is recovered in these paintings. It's worth hearing the tension in the phrase "still life," the something irreconcilable in the idea of life that has been brought to a pause. In Roberts's paintings, a balance is being worked out between animate and inanimate, between a cluster of old-fashioned roses, still respiring, and the vase in which they stand, between the lemon and the knife that cleaves it. Obliquely, the phrase "still life" directs attention to the motion of life itself, the movement of time, and when you become aware of it, you suddenly see the temporal harmony in these paintings. The china will not wilt like the roses or the hyacinths. The bone-handled fork will never spoil like the oysters that share its plate. Against the expedient ripeness of every fruit, every flower, there is the permanent, yet almost visceral ripeness of objects with which we would never associate the word: a pair of garden pruners, a tube of paint, a lipstick, a box of crayons.

And against all of this there is the enduring ripeness of the paintings themselves. There are sketches and studies here, in grisaille and in pencil, but they are self-contained works, complete if frag-

mentary. The immature stages of the finished paintings—the preparation, the ground painting, the second thoughts and first intentions—are hidden from us, implicit in the final work the way the blossom is implicit in the ripe apple. The viewer cannot sense the different rates at which different oil colors dry, the shades of translucency or opacity the paints lose or gain on the canvas over time. It takes more than a detailed inspection of these paintings' surprisingly irregular surfaces to realize that each of the minute effects on one of Roberts's canvases comes to the convocation of the whole at a pace all its own and that the painter's work is a kind of orchestration.

What we see as transliteration—rendering a peach's organic blush in inorganic oil paints—is actually invention. Because we believe we understand the convention of still life, what is hardest to see in these works is the discoveries they contain. Roberts's paintings do not mirror actuality. They invoke it. The reality they present is an idea, not a fact. They lend the viewer a momentary grandeur of perception that actually belongs to the painter. We glimpse Danaë through Zeus's eyes, not those of her timorous father. She is still chaste, but she radiates with opulent corporeality. She has marvelous ankles.

One of the oldest habits in looking at paintings, as old as the effort to recognize, is the iconographic habit of reading paintings in terms of conventional meanings. If the sheet were crimson instead of gold, then the woman recumbent on that Manhattan sofa couldn't be Danaë. If she were seated by an open window with a vase of lilies at her feet, then she would be someone else altogether, someone far less profane, if no less divinely pregnant. The iconographic habit has steadily diminished as the repositories of emblematic associations become less familiar, less instrumental to the artistic sensibility. It is as though the great indices of mythological meaning had been disassembled, and in the wake of iconography there came something more purely phenomenal, a way of attesting to the world in which symbolic meaning was superfluous. But even the most purely symbolic artists, painters of Nativities and Annunciations and Depositions from the Cross, find themselves seduced by the phenomenal splendor of the world, called upon to witness its specificity. That attesting has been going on for centuries, and in Roberts's work it is still going on.

Even in Roberts's still lifes, you sense an iconographic edge again and again, a feeling that the lipstick in *Lipstick, Pill Box and Garden Roses* cannot merely mean a lipstick. What is all that clarity for, if not to suggest some other significance? But Roberts paints in a world whose objects have reabsorbed their extended, iconographic meanings and are only themselves. That reluctance is their charm. When the combinations are simple—pansies, pear, pocket-watch; chevre, fruit, roll—the objects in these still lifes cling to their secular identity. They evoke a manner of living more than a manner of meaning.

But when the painting is *Interior, Evening*, something different takes place. Though it lacks an openly allusive title like *Danaë* or *Venus and Adonis, Interior, Evening* suggests the incarnation of a mythology so familiar that it has become invisible. Its iconography is emotionally intelligible but just out of rational reach, hidden, in a sense, by the domesticity of the setting. The room falls slightly away from true perspective, dividing at the doorjamb in the center of the painting. The mirror reflects a recess from farther within the interior, and that recess is mirrored in the composition by a panel of night sky, a glimpse of twilight over the rooftops of the Upper West Side. The objects of yet-uncomposed still lifes lie scattered across the bureau, including the pillbox that appears in *Lipstick, Pill Box and Garden Roses*. The model ambiguously poised to raise her slip— to change? to undress?—is Betsey Roberts or Danaë or Venus or Mary, depending on how you think about such things.

But this woman, whoever she means to be, is surrounded by the penumbra of her world, the clothes already chosen or awaiting her choice, the book on the bed, the dressing robe on the door hook. We are all surrounded in the same way in each of our lives, caught every moment in a composition of the intentional and the unintentional, framed by accidents of taste and fallacies of purpose.

From time to time, we stop and sense the mood that arises from certain configurations of light and posture, array and disarray. At those moments, if you pay close attention, you can almost detect the course of the myth to which you belong, the part you play, whether the part is fearful father, chaste daughter, rampant god, or some other figure in one of the unending, ever-varying narratives of betrayal and fulfillment that wreathe this world. You read, in other words, the iconography of the self. *Interior, Evening* acknowledges that awareness, even in its portrait of a woman who is lost in thought.

The stories that lead into and out of *Interior, Evening* are infinite and, in the end, impermissible. We have only the one indecipherable moment. But that is enough. We recognize the instant, even if it has no name. It is stolen. The day has been too short and more than long enough. The night outside, still glowing in the distance, is both an invitation and an enclosure. There is just the grace of this one brief transition, the left leg extended, the back taut, the hands knurled. There is perhaps an ache in the painter's eye at what he sees, an ache at the thought of his own clear-sightedness.

Stone Roberts, holding his dog Molly, with his wife, Betsey. Photograph by Lindy Smith, August 1997

9

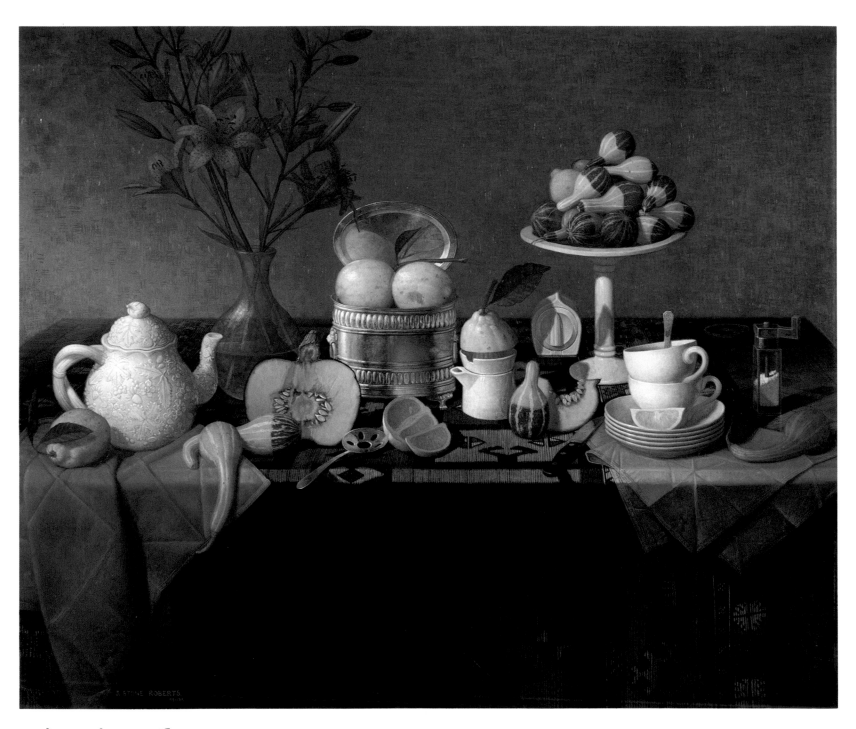

LEMONS, LILIES AND GOURDS
1986/87
Oil on canvas, 40 x 48 in.
Private collection

THE COURAGE TO PAINT


Charles Michener


Lemons, Lilies and Gourds, a large still life that Stone Roberts painted for his parents in 1986/87 occupies pride of place in his mother's living room in Asheville, North Carolina. At first glance it seems right at home among the fine antiques, silk upholstery, and oriental rugs, so well mannered are the harmonies of its meticulously rendered objects and luminous, mellow colors.

The more the eye roams the painting, however, the more problematic the work becomes. Why does the light intensify rather than diminish as it travels away from the source across the changing whites of the Belleek china? What is the plastic kitchen timer doing there, set—somehow ominously—at zero? Why, for all the painting's surface amiability, does it seem so *tense?*

Clearly, as in the still lifes of seventeenth-century Dutch painting, some kind of "story" is being implied. But those arrangements of half-eaten fruit, flowers, and household objects were allegories with clear meaning—reminders of human *vanitas*. This painting only proposes the possibility of a narrative; the viewer is left to make up the story himself.

What is going on here? Are we in the hands of a young fogy who is trying to bring back the lost and dubious art of Salon painting? Or is this yet another fashionable jester for whom academic painting is a put-on in disguise?

Neither assumption could be further from the truth.

When Stone Roberts was about five (he was born in 1951), he climbed up on one of his parents' bookshelves and pulled down a slim, illustrated volume called *Fifty Centuries of Art,* published by the Metropolitan Museum of Art. It made no difference that the book's reproductions of old-master paintings were of poor quality: the child's imagination was seized by these strange, inexplicable images. He recalls the "mysterious charge" he got from Andrea del Castagno's *Martyrdom of St. Sebastian,* Paolo Veronese's *Mars and Venus United by Love,* and Lucas Cranach's *The Judgment of Paris.* When he asked his parents if Albrecht Dürer's *Hare* was a real rabbit, he had to be told over and over again that it wasn't real: Somebody had painted it.

Somebody had painted it. How could a rabbit be pulled out of paint? The notion that one could transfer what one saw onto a piece of paper astonished him. Even more astonishing was the way these artists—whose names meant nothing to him—created images that were powerful in and of themselves. "I never confused them with photographs," he recalls. "And I immediately knew they were not like the illustrations I saw in children's books. These were images that lived in a world of their own. I had little interest in whether they were telling a story or not. I was consumed by their sheer visual presence. And I knew somehow that they were very old. I felt it miraculous that they spoke so directly to me through time. Most of all, I was amazed that a person could put so much together out of his imitation and make it all *fit.*"

The urge to create is, in good part, the urge to resolve. For what is art but an alternative reality in which the things that don't normally fit are made to fit? There was a lot about the childhood of Stone Roberts that didn't quite fit. Situated in the Blue Ridge Mountains, Asheville has prospered as a resort and health spa for wealthy northerners, many of whom settled there. What it became wasn't one thing or another: not quite a small town, not quite a city (its population remains about 60,000); not quite northern, not quite "Old South."

It was a place of sharply disparate cultures. There were the mountain people, rich in crafts and folk music. There was the exotic shadow of Black Mountain College, which refugee European intellectuals had made the spawning ground of the American château, complete with its own "feudal" village, constructed at the turn of the twentieth century by the wealthiest northerner of all, George Vanderbilt III. The largest private house in America, with a park laid out by Frederick Law Olmsted and sumptuous, art-filled rooms designed by Richard Morris Hunt, it was a fairy-tale vision


11


of the Old World—right next door to the affluent neighborhood of Biltmore Forest where the Roberts family lived.

Inside that household there were disparate elements as well. Mrs. Roberts was the daughter of a distinguished family from Nashville, Tennessee, a well-settled woman who personified Old South poise and graciousness. Her husband, an Asheville native, was a self-made man who had put himself through medical school by the age of twenty-one and become a much-admired dentist.

"He was highly aesthetic," says Robert of his father, who died in 1991. "He loved classical music and beautiful things and he was an excellent draftsman. When I was little, I loved watching him make drawings, mostly of people, which I would then copy or trace. But he was a restless, unhappy soul—sentimental one moment, stern the next. His volatility ruled the family. Outwardly, we lived a well-ordered life—country club, church, charities. Within, things were a lot more complicated."

Despite their shared aesthetic interests, the son felt a strange antagonism from his father. Not until he was beginning to become an established artist—a choice of profession his father initially opposed—did he begin to understand why. One day the elder Roberts confessed that as a young man in the Depression he had dreamed of becoming a serious painter himself, only to abandon those dreams for a more responsible career.

Roberts felt comfortable with the settings of his upper-middle-class upbringing, but uncomfortable with the rules that went along with them. He shone in art classes, but it never occurred to him—as it has for so many young Americans—to see art as a way out. In 1969 he entered Yale, headed—he imagined—for a career in law or business. In the fall of his junior year he was accepted into a drawing class taught by the figurative painter William Bailey. Copying from old masters as well as from life, he saw—"under Bailey's very rigorous, very critical eye"—what drawing could do on the highest level. He went to the 1971 exhibition of Bailey's still lifes and figure paintings at the Robert Schoelkopf Gallery in New York and was struck by their "absolute seriousness."

Still, he was a generation apart. Bailey and his peers had kept the realist tradition alive against the waves of Abstract Expressionism, Conceptualism, and Minimalism. But a defining element of Bailey's work—like that of Fairfield Porter, Philip Pearlstein, Alex Katz, and others—was its ongoing dialogue with modernism. Aesthetically they had severely reduced their concerns. Emotionally their work was austere.

What Roberts loved about Renaissance and Baroque painting was its formal richness, its emotional and psychological content, its sheer beauty of *paint.* In the 1960s, the concerns of art had been broken down into "problems"—problems of perspective, color, concept, and so on. Why couldn't there be a painting that brought it all back together?

He looked for possibilities in a wide variety of work, ranging from Philip Guston's lyrically abstract paintings of the 1950s to Joan Mitchell's lush, coloristic abstractions; from Lennart Anderson's engaging figure compositions to the haunting interiors of Paul Wiesenfeld; from Francis Bacon's portraits, with their mix of art history and obsessive, unrestrained subject matter, to the psycho-dramas of Balthus.

In June 1972 he attended Yale's summer school for art in Norfolk, Connecticut. There, encountering students from art schools around the country and Europe, he realized how out of the mainstream his realistic drawings and paintings were. To his dismay, many of his classmates dismissed his work out of hand. It was an experience that left him deeply distrustful of the purported avant-garde.

At the Tyler School of Art in Philadelphia, where he did graduate work, perhaps the best thing that happened to him was being taken into the household of Julius Rosenwald II and his wife as a sitter for their dog. Julius Rosenwald's father had amassed one of the world's great collections of prints and drawings (then housed in the Avelthorpe Gallery), and Roberts was elated at being allowed to actually hold work by Dürer, Cranach, Rembrandt, Hogarth, Goya, Cassatt, Degas, Picasso, and Matisse.

The following June he got married and went to Rome to finish his fine-art studies. There he studied with the painter Ronald Markman, who was visiting from the University of Indiana. With Markman's encouragement, Roberts began the difficult transition from drawing to painting.

Living in Rome brought him back to his earliest sense of art. Here, in the setting of its creation, art was an everyday reality. The experience was both exhilarating and sobering. He wanted to make paintings on the highest level, but he realized it would take him years to master even the fundamentals. How, in the meantime, was he to keep life and limb together? When he and his wife, Betsey, returned to New York, he didn't want to teach art and he didn't want to work in a gallery. He took a job in a Wall Street bank.

For five years Roberts worked successfully in corporate finance at Irving Trust. He rented himself a studio, where he only had time for drawing during odd hours. He did well at the bank but felt increasingly frustrated trying to balance two lives. Approaching thirty and on the brink of taking a new job in an investment bank, he agreed to what his wife had been urging him to do for years. In January 1981 he quit the bank and he and Betsey left New York for an old plantation house in the Mississippi Delta. "What was up for grabs," he says, "was whether I could fulfill who I was." For months, while they renovated the house, Roberts "sat and thought." He tried his hand at still-life drawings, then a series of painted figures in grisaille. Before leaving for a month's trip to Europe he picked up a paperback copy of a recently published novel by Shirley Hazzard called *The Transit of Venus*. As much as any work of art can, it changed his life.

What was it about the novel that stirred his painter's ambitions so deeply? *The Transit of Venus* was manifestly in the grand literary tradition. Its cultivated heroines—two orphaned Australian women adrift in London and New York—could have stepped out of Henry James. Underlying the events was a Victorian sense of destiny: the ending, a plane crash, seemed as ordained as that of a novel by Thomas Hardy.

But this novel was unmistakably contemporary. For all their passionate entanglements, its characters were modern—irretrievably alone. Roberts was overwhelmed by the novel's lucid complexity, its high-wire balance of tradition and idiosyncrasy. Here was a work of art that resonated the way he wanted his art to resonate. He returned to Mississippi with the courage to paint.

In 1981 the Pennsylvania Academy of the Fine Arts mounted a landmark exhibition, *Contemporary American Realism Since 1960,* that revealed the enormous diversity of painters who were emerging from the backwater of modernism. Roberts didn't see the show, but he bought and studied the catalogue. From its essays by Frank H. Goodyear, Jr., he copied down a number of quotations. Among them was this:

> Perhaps the reason that narrative painting has limited advocacy today is that artists are unwilling to take the ultimate anti-modernist position of allowing content to dominate form, recognizing, moreover, that the success of their narrative works may be heavily dependent on borrowing historical pictorial conventions. . . . It is disquieting that so many realist artists, abundantly gifted in painting what they can see, stop at recording with visual accuracy, eschewing the delights and possibilities of a narrative voice.

In June 1982, *Newsweek* put William Bailey's *Portrait of S* on its cover for an article by Mark Stevens trumpeting "The Revival of Realism." Newsstands across the country took the issue off their racks in the face of complaints about a bare-breasted young woman, painted in Renaissance light, on the cover of the news magazine. For Roberts, the Goodyear catalogue and *Newsweek* article were beacons of encouragement. He plunged into his first large-scale realistic painting.

Janet was begun in April 1982 as a not-so-simple challenge: to paint a figure in an interior. Over the two years he took to finish it, Roberts worked its various parts as if he were writing a novel, trying

to perfect one "chapter" (for example, the oriental rug) before moving on to the next (the still life), then going back and reworking them until they fit into his sense of a coherent visual drama. Some elements, such as the dog (Roberts's English cocker spaniel, Luke), were worked out first in drawing. Others, such as the still life, were painted directly onto the canvas. There was a great deal of overpainting. The figure of the young woman—a teller in a local bank—went from a casual, open pose to one of apprehensive self-protection. To heighten the sense of narrative possibilities, Roberts placed objects enigmatically—a broken wine glass, a fallen amaryllis blossom.

The result might be criticized as a patchwork for trying to combine so many subjects of traditional painting. Morever, *Janet's* rather muted spectrum of light and color shows that Roberts was still feeling his way as a colorist. But for a painting that is so clearly a process of self-education, it is remarkably convincing. Nowhere does it cheat or go slack, not even in the deepest shadows. The composition is beautifully worked out with the diagonals making subtle counterpoint to the off-centered, frontal placement of the young woman and her haunting, surprised gaze. Best of all, *Janet* has what would become a hallmark of Roberts's work: an almost palpable edge derived from the tension between the certainty of the painting's formal resolution and the uncertainty it evokes.

While wrestling with this ambitious work, Roberts executed three smaller paintings in which he combined a reverence for the nature's realities with an irreverence as to how they could be re-ordered in his reality. In *Mineolas Still Life* (1983), one sees the beginnings of an original dialogue among traditional pictorial elements. Having placed the bright orange mineolas off to one side, Roberts established a precarious balance with the white shapes of crockery and napkin, then echoed that tenuous conversation in the colors and shapes of the oriental rug. In *Parrot Tulips Still Life,* he pushed light and color with more confidence, creating an almost shocking play among pinks, orange, and reds. In *Cantaloupe Still Life,* the busiest of the three paintings, he made a particular drama out of the tightly chaste form of the lemon and the violated open canta-loupe, oozing pulp and seeds.

Traditional still lifes were occasions for contemplation, but these paintings take the viewer aback. Their homely objects seem not so much eternal as eternally restless—about to pop right out of the picture plane. It is not accidental that they are reminiscent of Caravaggio and his followers: Roberts decided to paint them after seeing an exhibition at the National Academy of Design in New York, *Still Lives from the Italian Golden Age.* But they are anything but academic exercises. Roberts had taken note of Goodyear's observation that "much of the best contemporary still-life painting lives in limbo between the artist's need to describe forms objectively and, at the same time, to transcend description." Already he had mastered one of the imperatives of the genre: to make the familiar strange.

In the fall of 1982 Stone and Betsey moved back to New York. Along with *Janet,* the three still lifes were subsequently accepted by the Robert Schoelkopf Gallery. The smaller paintings found immediate buyers. Several months later, William Lieberman, director of twentieth-century art at the Metropolitan Museum of Art, came into the gallery to look at several more established artists. It wasn't long before the Met acquired *Janet*—a painting by an entirely unknown artist—and put it on display at the inaugural show of the museum's new contemporary wing.

In the summer of 1984, Roberts made human dialogue the actual subject of his second large painting, this one twice as big as *Janet.* Marking the tenth anniversary of his marriage, *The Conversation* was inspired as well by the story of Dido and Aeneas—the first Roberts painting to find a starting point in classical mythology or the Bible. Here, the episode in *The Aeneid* in which the Trojan prince tells the queen of Carthage about the fall of Troy is updated to a social gathering in contemporary New York. While guests mingle ambiguously, a Cupid figure reaches for a bowl of fruit, a figure representing Rumor whispers to another guest. The lovers, played by the artist and his wife—he in black tie, she reclining

odalisque-fashion—are caught not in a quarrel between the gods but in the problematic grip of their mutual regard, a relationship in which the balance of power seems very much in flux. For someone who had only been painting seriously for two years, *The Conversation* was an audacious leap forward—from the one-figure scene of *Janet* to an immensely complicated tableau of ten figures. One of its challenges was to choreograph them with gestures that struck a balance between mythical and psychological time. Among other themes, the painting is concerned with masculine versus feminine— as expressed in the contrast between the sharp-elbowed Aeneas figure on the left and the cascade of womanly arms on the right.

In *The Dressing Room,* his last work completed for his first one-man show at the Robert Schoelkopf Gallery in 1986, he pulled it all together: a complex geometry of echoes and rhymes (the reflections of the Betsey figure in the mirror), whimsy (the hair dryer), a vibrancy of light and color, and a vaguely sexual aura, evoked by the implied presence of the male artist, who is unseen by anyone in this female world but his stand-in, the dog Luke.

When the Rosenwalds commissioned a painting from their former dog-sitter, he produced *Luke and Flowers.* It is a work that seems painted to both flatter and shock his fond patrons' cultivated taste—first with its virtuoso handling of the relationship between the pallid napkin and the oriental carpet, then with its frank depiction of the dog, which recalls George Stubbs for its articulation of an animal's physicality.

In 1988, Roberts was commissioned to paint a narrative from real life: the union of a husband, a writer, and his wife, a successful executive. What he created was a portrait of a marriage that may have been more probing than his subjects expected. The wife in *Portrait of a Marriage* is, as tradition dictates, in the foreground— not stiff-backed in a Victorian chair but seated on the carpet, half-demure, half-provocative, with the contents of her briefcase spread out before her. Behind her stands her husband, leaning awkwardly toward his computer. The arch he forms suggests the husband's conventional, protective role. But these two marriage partners seem completely disconnected in their self-absorption. Only their passing black cat pauses to complete this odd family circle, acknowledging by the tautness of its tail and the turn of head the disturbing undercurrents in the scene. By choosing to collaborate with the real world, Roberts opened himself further to elements that were out of his control, with results that feel less staged than his previous work.

In *Venus and Adonis* (1987/88) he achieved his most theatrical fusion of mythic and observable reality to date. Upon first glance, the painting seems like one of Peter Sellars's wildly irreverent stagings of grand opera. The goddess of love is now a prim New York matron, her lover a tennis player—judging from his tan lines. But one's inclination to dismiss this large work as a virtuosic folly is checked by the sheer intensity of the paint from the hot splash of sunflowers to the veins of the Adonis figure, the prominence of which indicates that he isn't dead but merely asleep.

What keeps this odd tableau from tipping over into melodrama is the remarkable orchestration of light. Unlike other contemporary mythic-realists, Roberts does not make classical or art-history allusions for instructional benefit. He regards mythical and biblical stories as "occasions" for paintings. But as his light—an eerie hybrid of the gold of the Italian Renaissance and a harsh New York day— falls across the scene, it suggests that the real death in this *Venus and Adonis* is the power of myth.

In his next figure painting, Roberts combined with a vengeance art history, biblical incident, and contemporary angst. *The Visit* subverts the traditional genre of card players, as exemplified by Caravaggio and Georges de la Tour, by recasting it with two young women in poses that suggest the visit of Mary to her cousin Elizabeth in the Gospel of St. Luke. One woman, ambiguously aggressive, has intruded on another, who is playing solitaire. The painting can be read as a narrative about two players in the gladia-torial game of 1980s yuppie materialism. At the same time that it luxuriates in the women's expensive garments, the painting implies that there is a good deal amiss behind their affluence. The disruptive

dog suggests the monkey figure in paintings of antiquity—symbol of sensuality in check. The spilled wine recalls the blood of Jesus, Mary's son, and what would eventually befall Him. The jarring contrast of its crimson color (in the unspilled glass) against the visitor's magenta jacket is the epiphany in this prickly vignette of a discordant friendship.

By now, Roberts has established the pattern of his self-education: after each figurative drama he would replenish himself with still lifes, such as *August Still Life* and *Red Sensation Pears,* in which he could push his handling of color, light, and form. Once again, what was being claimed was not so much nature's reality as the painter's reality.

In 1990, William Cecil, one of George Vanderbilt's two grandsons, commissioned Roberts to paint a family portrait to commemorate the centennial of Biltmore Estate. The canvas had to fit harmoniously at the end of one of Biltmore House's great rooms. Aside from depicting the family, another requisite was to show the accomplishments of the current generation in keeping the estate thriving.

For the better part of a year, Roberts worked on virtually nothing but *The William A. V. Cecil Family.* It would take a novella to put into words the enormous amount of historical, familial, and psychological information about Biltmore Estate and its present owners conveyed in this nearly seven-foot-square canvas. Among the work's many telling details (for example, the placement of the Western boot of William Cecil's only son and heir between the father's black town shoes) is one masterstroke: the replication of a painting by the nineteenth-century American artist Seymour Guy called *Going to the Opera.* In this last formal portrait of the Vanderbilts, executed in 1873, the family is seen playing public parts in the social swirl of the Gilded Age. In the portrait of their descendants, it is the private selves that are on display. Each is dressed according to individual choice. Except for William Cecil, the patriarch in business suit, each seems uncomfortable with being him- or herself and at the same time having to play such a public role as a member of the family. The Guy portrait hangs at the opposite end of the long room, adding its own voice to this complex dialogue between generations—especially in the figure of eleven-year-old George Vanderbilt, whose position at the table mirrors that of his grandson, Mr. Cecil.

Roberts began, with increasing boldness, to loosen some of the controls that imposed a certain stiffness on his earlier work. *Scissors, Frog and Garden Roses* signals a new forthrightness. By its rigorous tension between the softness of the no-longer-fresh roses and the sharpness of the implement that hastened their demise, the painting might be commenting on the artist's own ruthlessness as a painter. *Fruit, Kleist and Dahlias* suggests still greater self-exposure. Among the unlikely objects forced into each other's company are an overcrowded bouquet of wayward dahlias, sensual mounds of fruit, a cheap red corkscrew, the matchbook from a New York restaurant with two burnt matches, a piece of Bohemian glassware etched with a running stag, and a paperback collection of short fiction by Heinrich von Kleist, the German Romantic writer whose great theme was the conflict between ideal order and earthly catastrophe. The title story in the Kleist collection, "The Marquise of O," concerns the mysterious pregnancy of a noblewoman who, during a time of war, is both raped and saved from death by an unknown officer. Perhaps the complex arrangement of disparate objects does not beg understanding, but means only to ravish: to throw the viewer into a state akin to the voluptuous confusion experienced by the marquise.

Roberts is not a programmatic painter. He builds his visual narratives out of ideas and memories, no matter how seemingly trivial. Some time ago, a friend joked that a misunderstanding with a man had left her feeling like "Potiphar's wife." This chance reference to the Old Testament story of Joseph fleeing the advances of the wife of the pharaoh's chief stewart germinated in Roberts for nearly a decade. Over the years he collected representations of the story by such old masters as Guido Reni, Il Guercino, and Orazio Gentileschi. Ultimately, they became the foundations and echoes in a painting he completed in 1992. The painting is called *Paul and Caro* after another inspiration, which occurred to him while making

the preparatory drawing. Paul and Caro are the principal lovers in Hazzard's *The Transit of Venus*. One of the novel's climactic revelations is that their turbulent affair concealed still more turbulent affairs— a vortex of desire and betrayal. As the stars of this bedroom drama he cast himself and Betsey. *Paul and Caro* addresses the cross-purposes of self-exposure and concealment in marriage. While the Stone/Paul figure struggles to put on his raincoat—which all but conceals him behind its broad, canvaslike expanse—the Betsey/Caro figure sits on the bed, wrapping her nakedness with a sheet and clutching her lover's tie as hostage. The dog Luke, third member of the Roberts household, has been suddenly awakened. It is a story that implies a great deal, sounds a note of brooding melancholy, and explains nothing. Like every Roberts story, it is not about revelation but reverberation.

With *Paul and Caro* Roberts leapt into the Baroque. Whereas his previous scenes were played out in Renaissance perspective as if set behind a proscenium, this one takes place in a sharply tilted space: the figures are seen in subtly different perspectives, and the painter has taken considerable liberty with their relative scale. (It is clear that if the woman stood up, she would be a great deal taller than the man.)

Why, for all their dazzling assurance of construction, do these paintings seem so precarious? At the heart of this paradox is another paradox. Although they are as educated, sophisticated, and well traveled—at least to Europe—as any art of our time, these paintings are inescapably American. In their exactitude with objects, natural or man-made—in their obsession with the *thingness* of

things—they are as American as the heightened realism of William Michael Harnett and John Frederick Peto or the soup cans of Andy Warhol. In the painter's insistence on limiting himself to painting what he sees with equal attention to every figure and object, they are as "primitive" as the anonymous portraits of Colonial New England and rural landscapes of Grandma Moses. Their sense of the luminous world beyond art—and their labor to make that world more luminous through art—is as imbued with wonder as the Hudson River School vistas or the drips of Jackson Pollock.

More precisely, the driving concern in Roberts's art seems *southern* American in its yearning to arrest the reckless momentum of a democratic society that creates such a spiritual vacuum in its center—the force of which, as Alexis de Tocqueville wrote, makes "every man forget his ancestors . . . throws him back forever upon himself alone and threatens in the end to confine him entirely within the solitude of his own heart." What may be most American of all about Robert's paintings is their urgency to connect.

In the cartoon for his unfinished *Rest on the Flight into Egypt* (1992), Roberts casts himself as hovering angel, which is perhaps what every artist in this unruly universe aspires to be. This angel is no transcendent emissary, but an earthbound, bespectacled fellow in a raincoat—a man in his early forties who refuses to dress the part of the alienated modern artist, who still looks like a banker.

Talking about why he paints what he paints, Roberts cites this passage from the "East Coker" section of *Four Quartets* by T. S. Eliot: "Home is where one starts from. As we grow older / The world becomes stranger, the pattern more complicated. . . ."

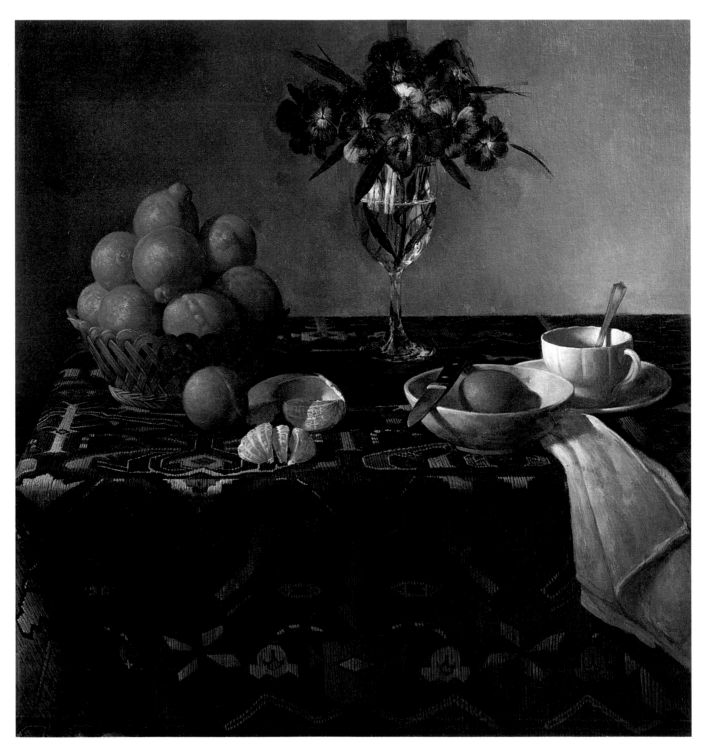

Mineolas Still Life
1983
Oil on canvas, 32 x 30 in.
Chemical Bank Collection, New York

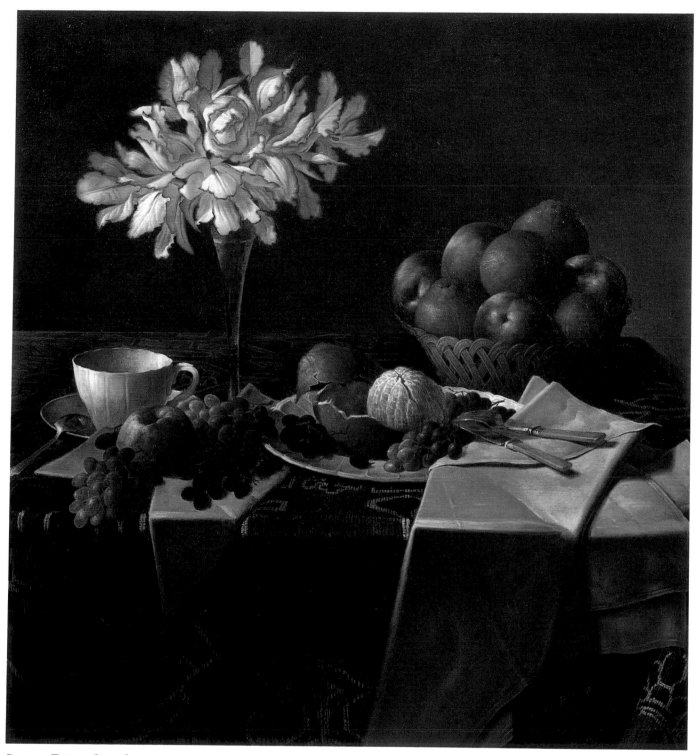

Parrot Tulips Still Life
1983
Oil on canvas, 32 x 30 in.
Collection Carll and Diane Tucker

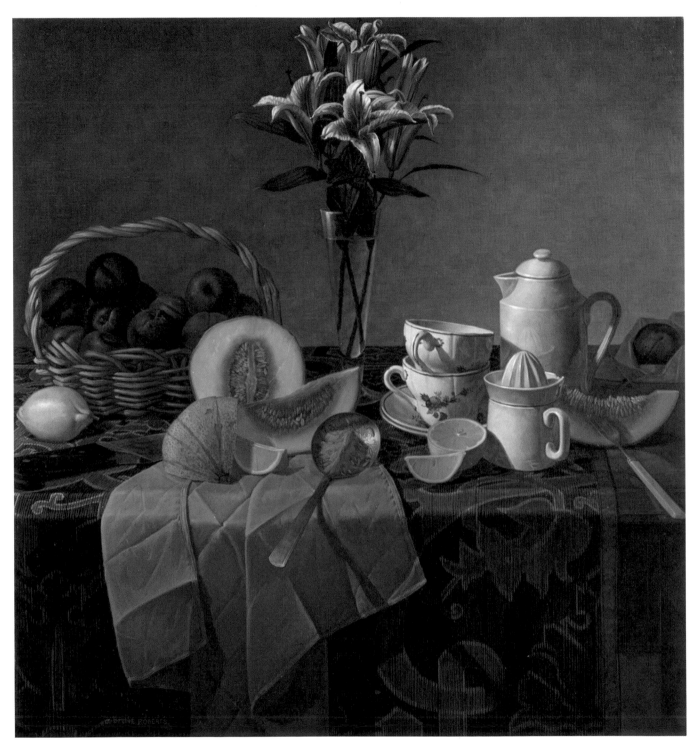

CANTALOUPE STILL LIFE
1985
Oil on canvas, 32 x 30 in.
Private collection, New York

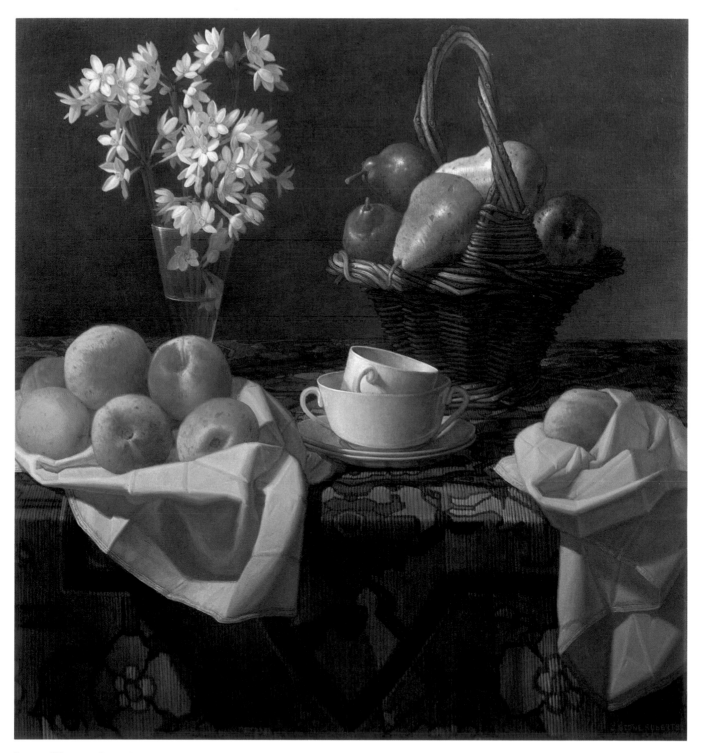

PAPER-WHITES STILL LIFE
1985/86
Oil on canvas, 32 x 30 in.
Collection Brooke and John Fowler

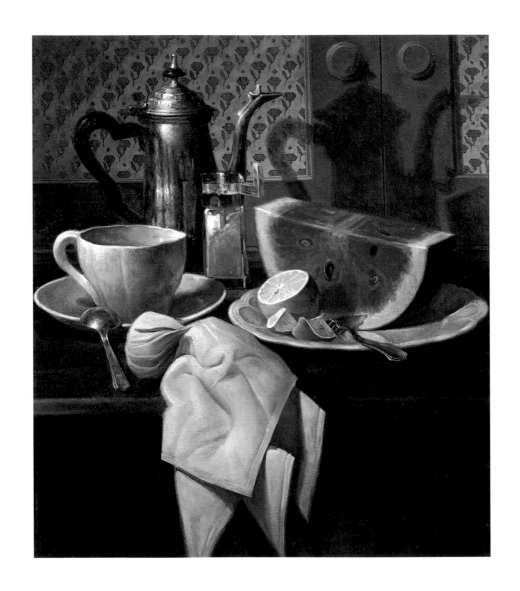

Watermelon Still Life
1983/84
Oil on canvas, 18 x 16 in.
Collection Allison and Donald Innes

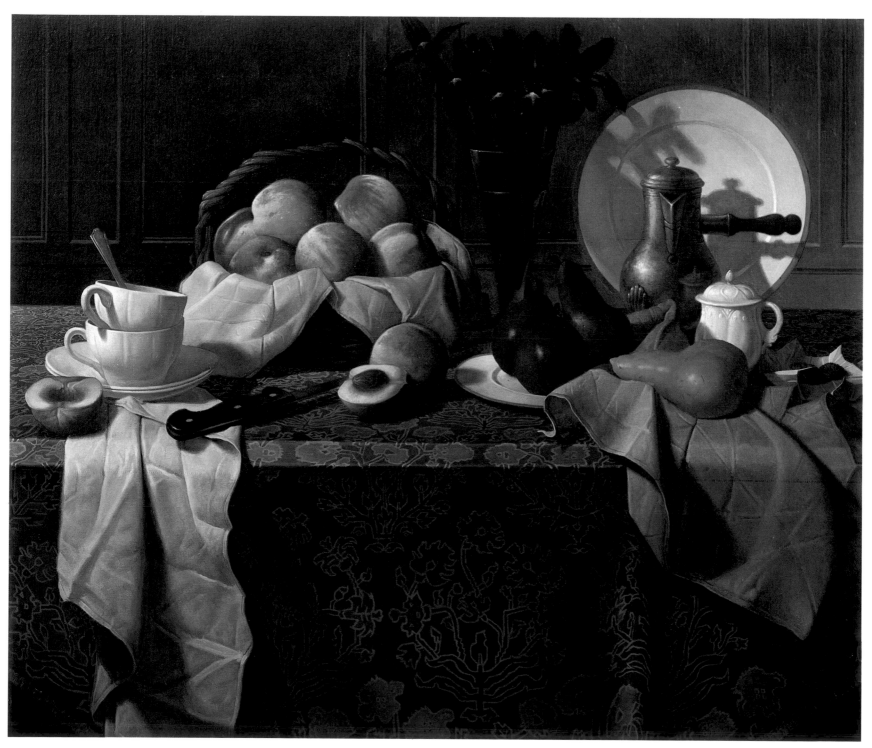

BLUE CLOTH STILL LIFE
1984
Oil on canvas, 30 x 36 in.
Private collection, New York

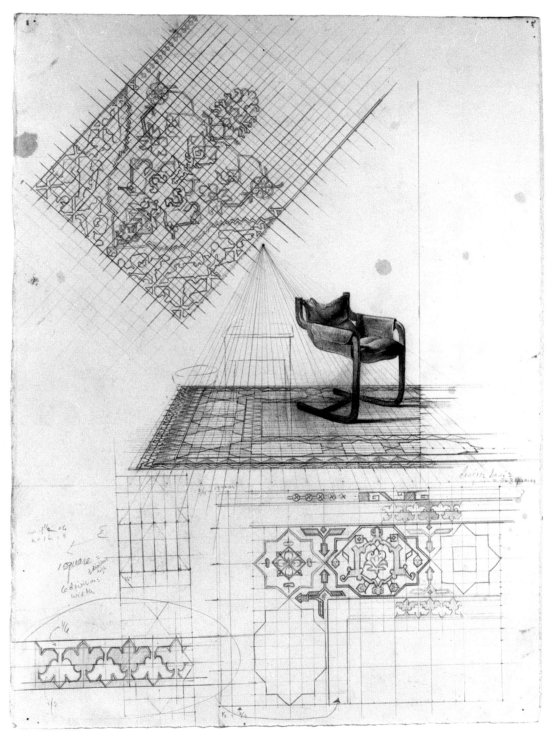

Perspective Study for *JANET*
1982
Pencil on paper, 15 x 11⅛ in.
Courtesy Salander-O'Reilly Galleries, Inc.

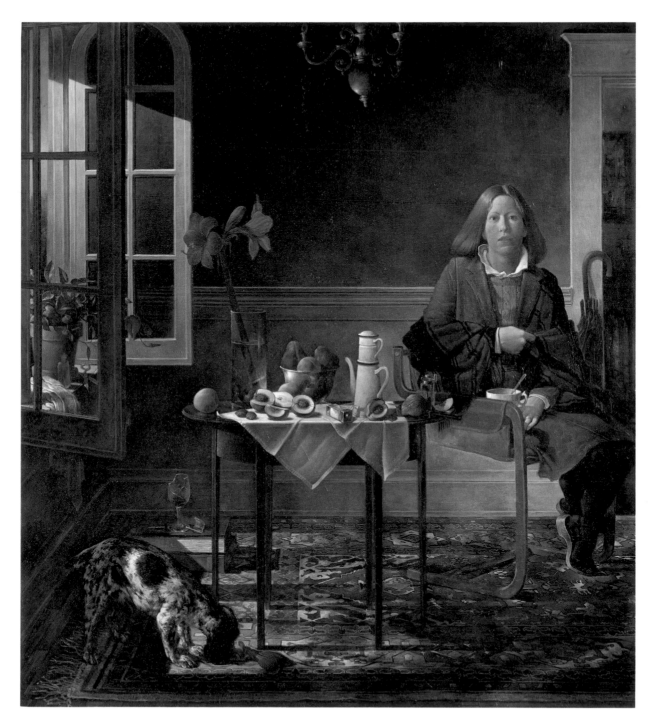

JANET
1982/84
Oil on canvas, 60 x 54 in.
The Metropolitan Museum of Art, New York
Gift of Dr. and Mrs. Robert E. Carroll, 1986

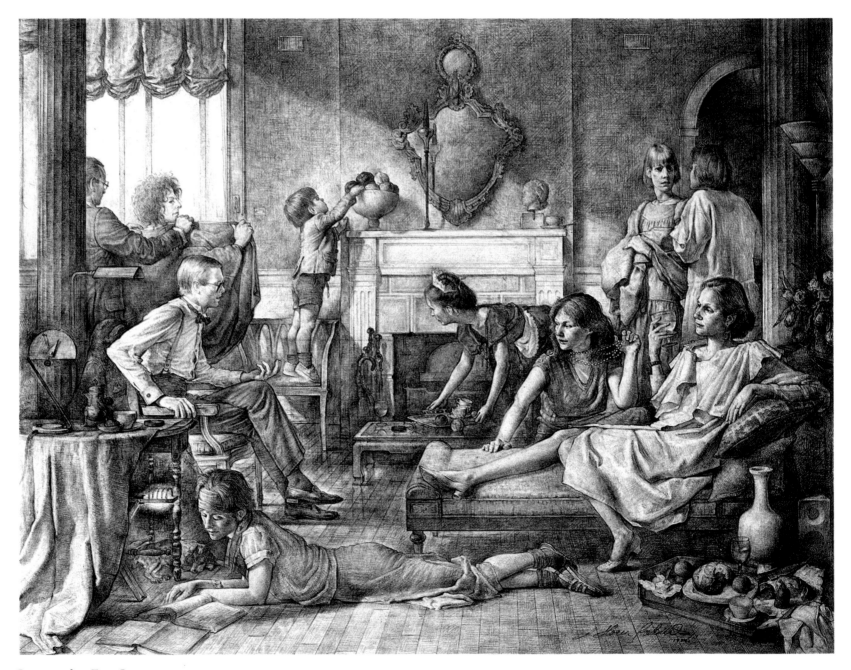

Cartoon for *THE CONVERSATION*
1984
Pencil on paper, 16 x 20 in.
Private collection, New York

Study for *The Conversation (JSR)*
1984/89
Pencil on tinted paper heightened with white
14½ x 17 in.
Private collection

Study for *THE CONVERSATION (CHINTZ PATTERN)*
1985
Colored pencils on paper, 9⅝ x 7 in.
Private collection, New York

Study for *THE CONVERSATION (EMR)*
1985
Pencil on paper, 12¼ x 10¼ in.
Private collection, New York

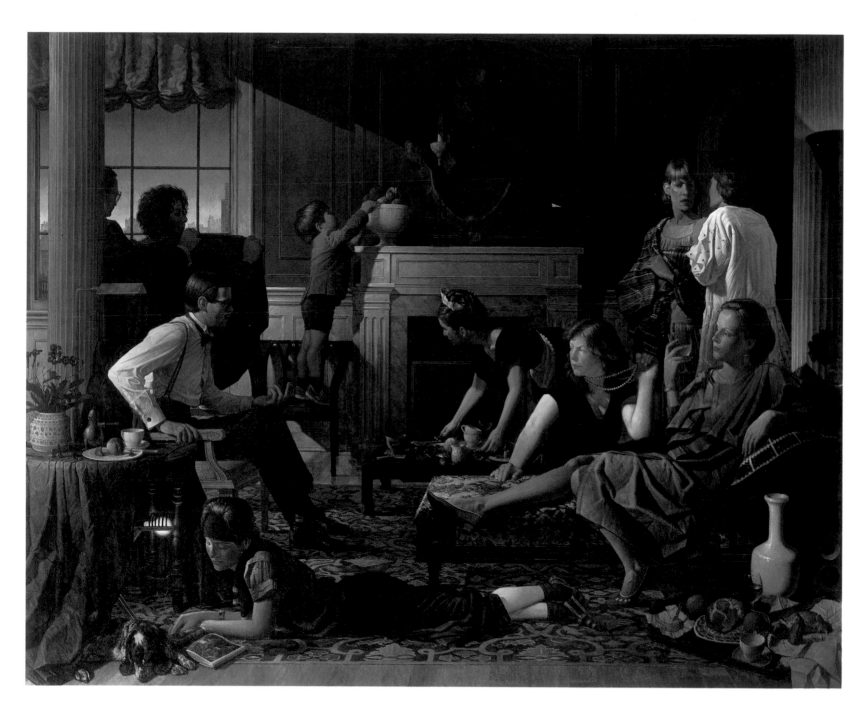

THE CONVERSATION
1984/85
Oil on canvas, 72 x 90 in.
Collection Mr. and Mrs.
Frederic D. Wolfe

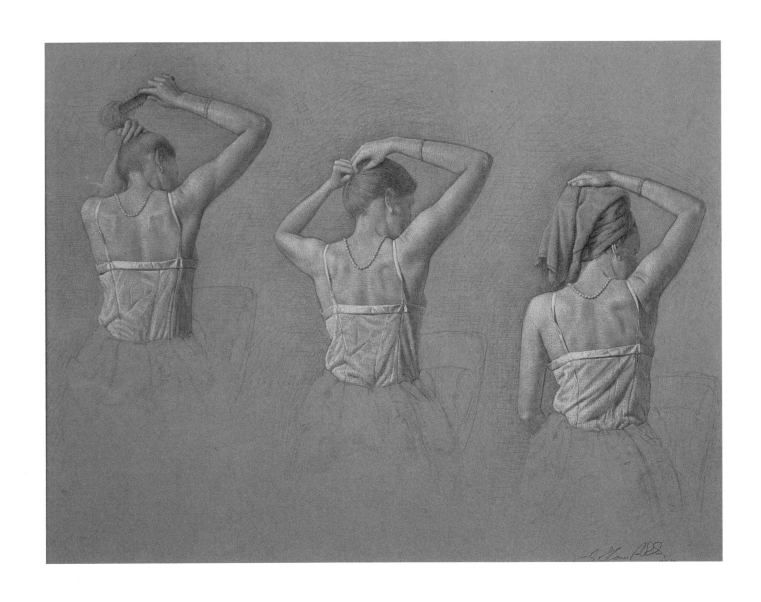

Study for THE DRESSING ROOM (EMR)
1986/89
Pencil on tinted paper heightened with white, 13⅛ x 17⅛ in.
Collection Carl Spielvogel and Barbaralee Diamonstein-Spielvogel

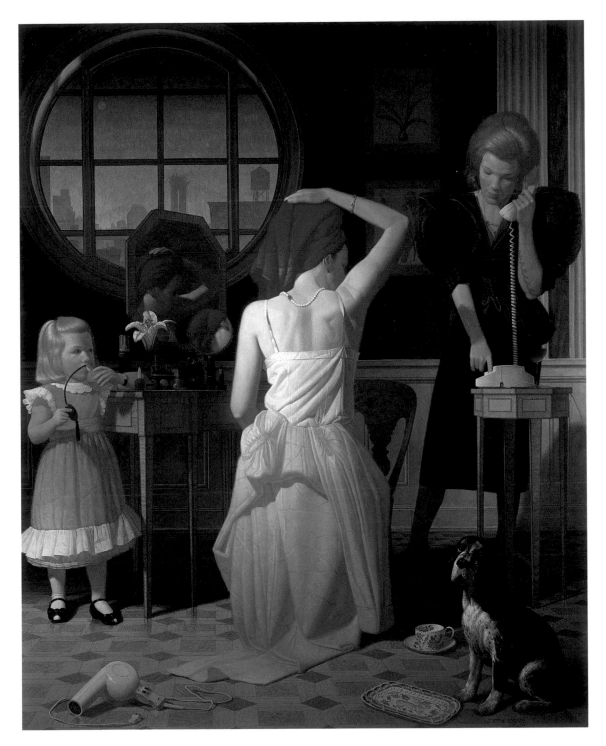

THE DRESSING ROOM
1986
Oil on canvas, 60 x 48 in.
Collection Mr. and Mrs.
Richard L. Menschel

31

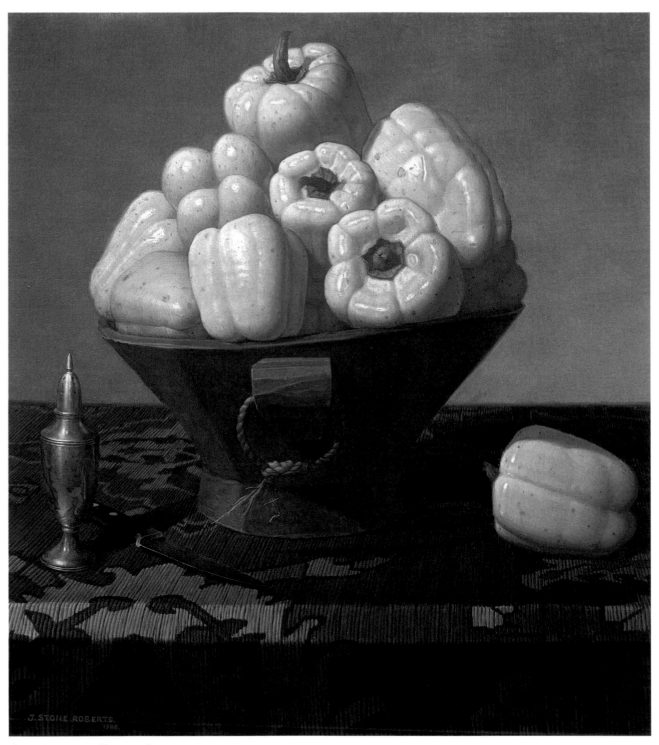

STILL LIFE WITH YELLOW PEPPERS
1986
Oil on canvas, 22 x 20 in.
Wellington Management Company Collection,
Boston

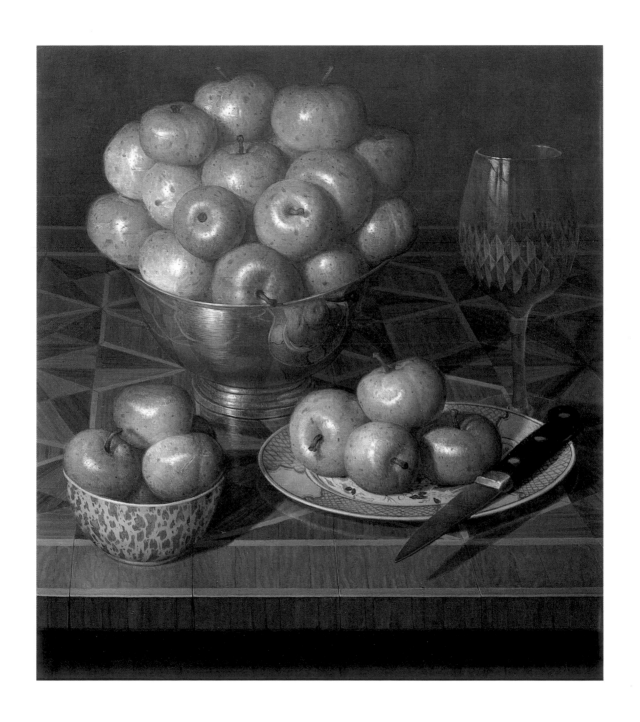

STILL LIFE WITH LADY APPLES
1986
Oil on canvas, 18 x 16 in.
Private collection, New York

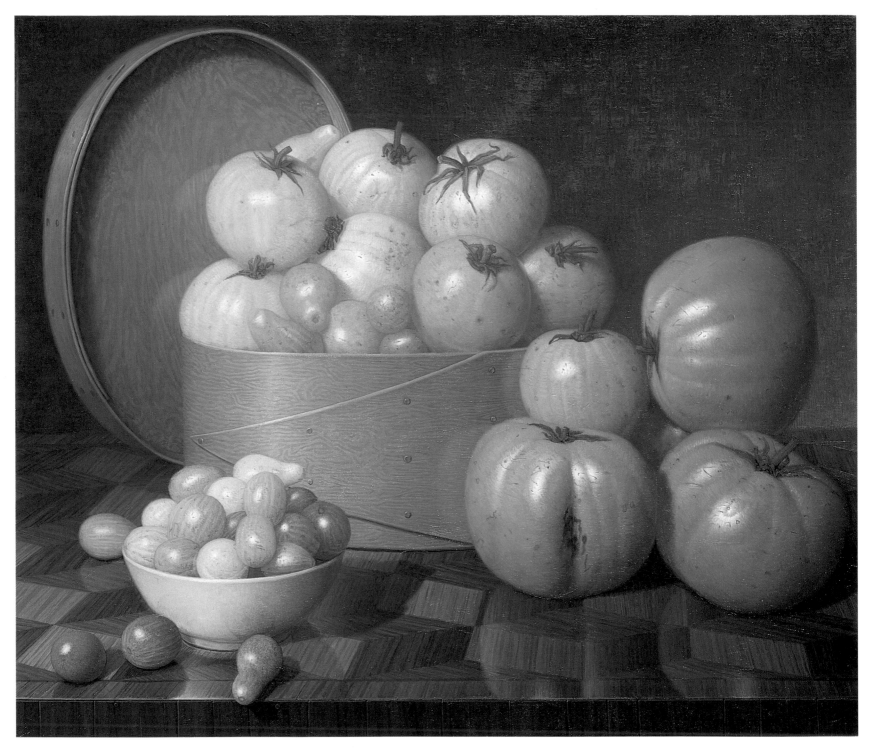

Yellow Tomatoes
1987/88
Oil on canvas, 18 x 21 in.
Collection Mr. Jerald D. Fessenden

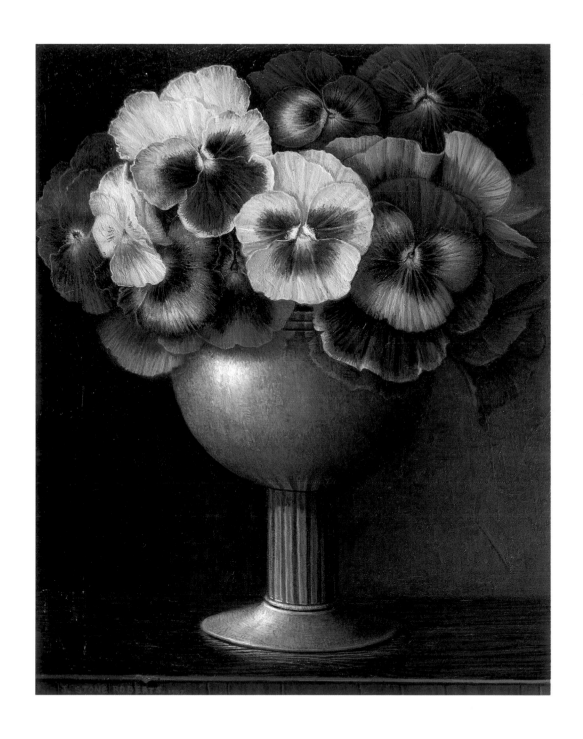

PANSIES IN A GOBLET
1987
Oil on paper, 9⅛ x 7⅜ in.
Courtesy Wendy S. Hoff Fine Arts, Inc.

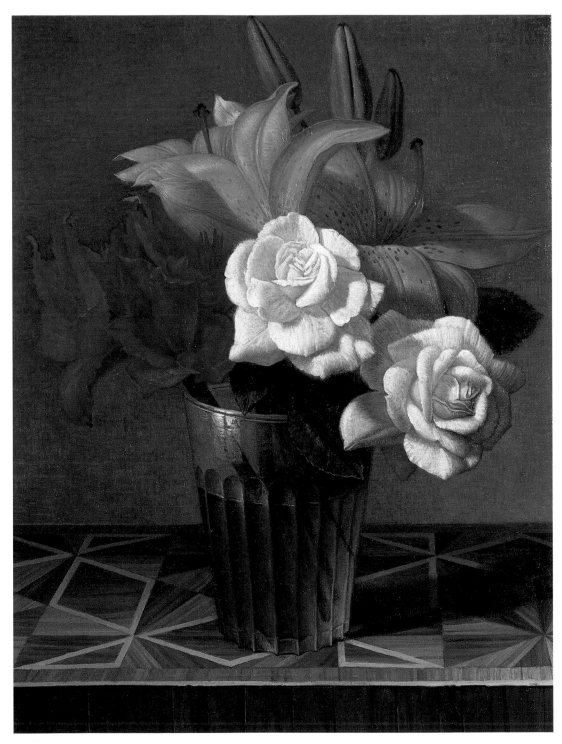

FLOWERS IN A GLASS
1987
Oil on canvas, 13 x 10 in.
Wellington Management Company
Collection, Boston

36

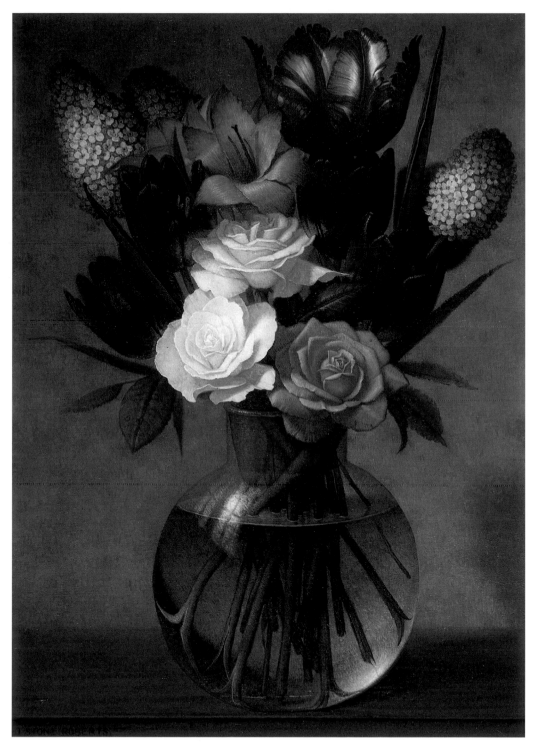

Winter Bouquet
1987
Oil on canvas, 21 x 15 in.
Collection Mr. and Mrs.
Graham Gund

37

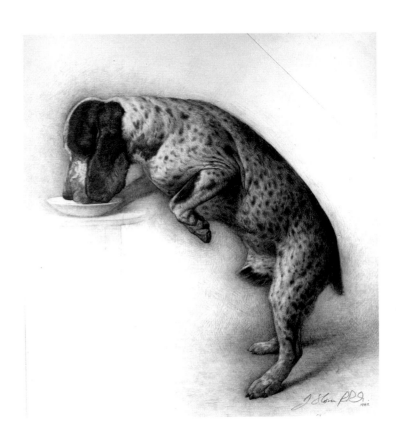

Study for *LUKE AND FLOWERS*
1987
Pencil on paper, 10½ x 10 in.
Private collection

Preparatory Drawing for *LUKE AND FLOWERS*
1987
Pencil on paper, 15 x 11⅛ in.
Collection Mrs. Robert Schoelkopf

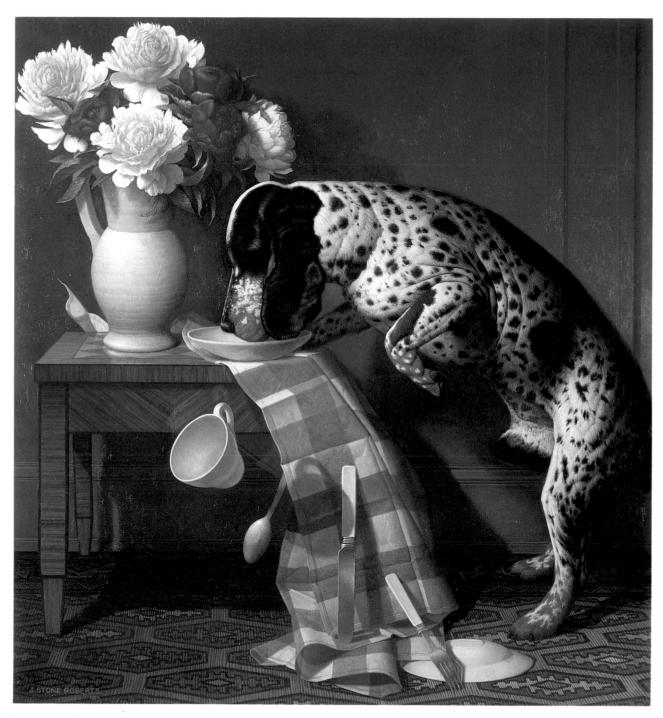

Luke and Flowers
1987
Oil on canvas, 32 x 30 in.
Collection Mr. and Mrs. Julius Rosenwald II

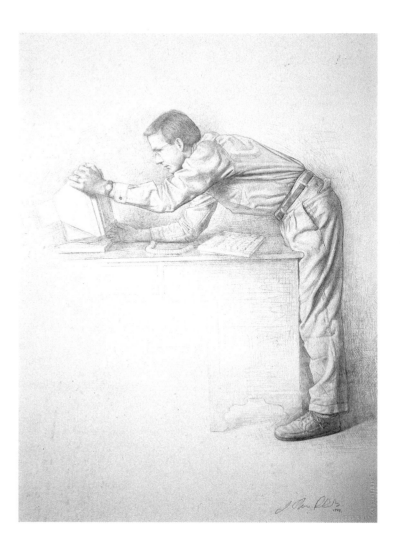

Study for *PORTRAIT OF A MARRIAGE*
1988
Pencil on paper, 14½ x 10½ in.
Private collection, New York

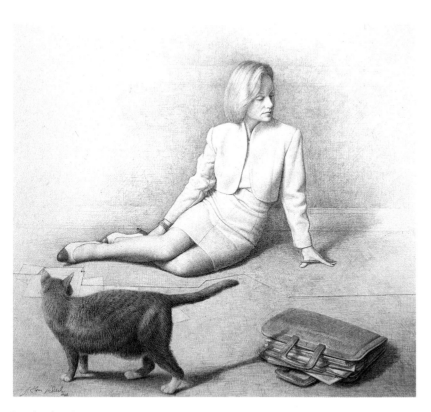

Study for *PORTRAIT OF A MARRIAGE*
1988
Pencil on paper, 11 x 12 in.
Private collection, New York

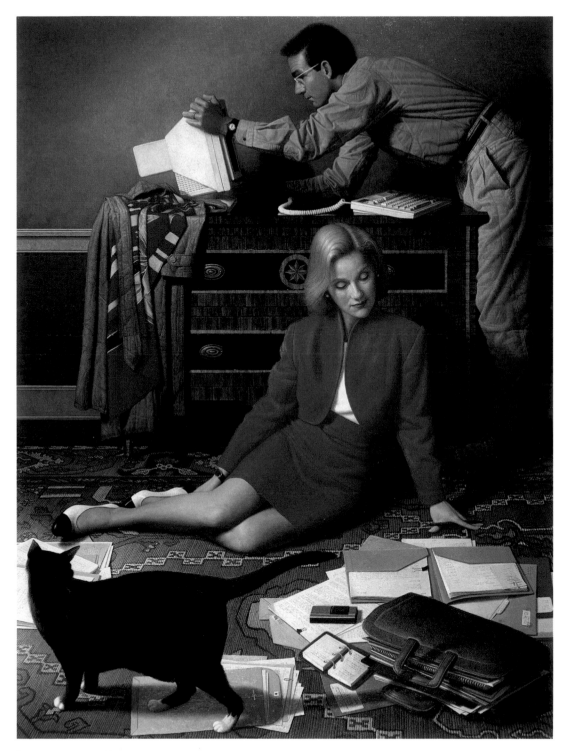

PORTRAIT OF A MARRIAGE
1988
Oil on canvas, 47 x 35 in.
The Flint Institute of Art,
Flint, Michigan

41

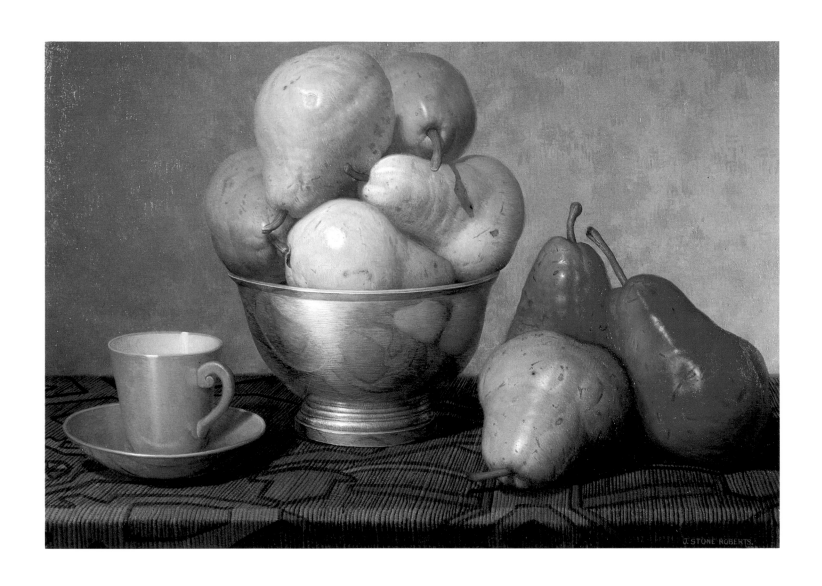

PEARS
1987
Oil on canvas, 16 x 23 in.
Collection Mr. and Mrs. Alan J. Hruska

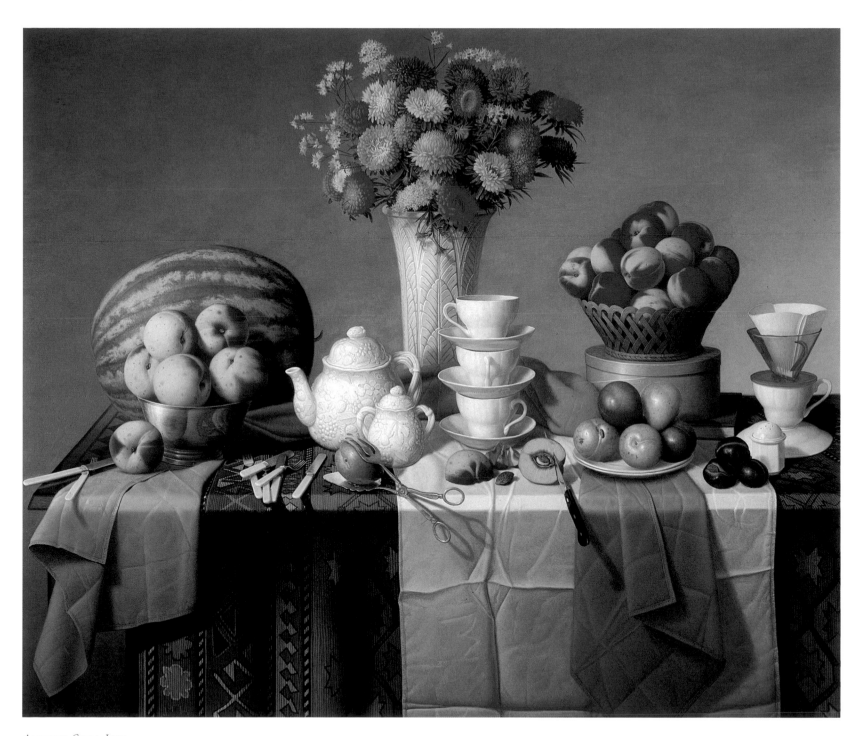

AUGUST STILL LIFE
1989
Oil on canvas, 46 x 54 in.
Collection Mr. and Mrs. Alan J. Hruska

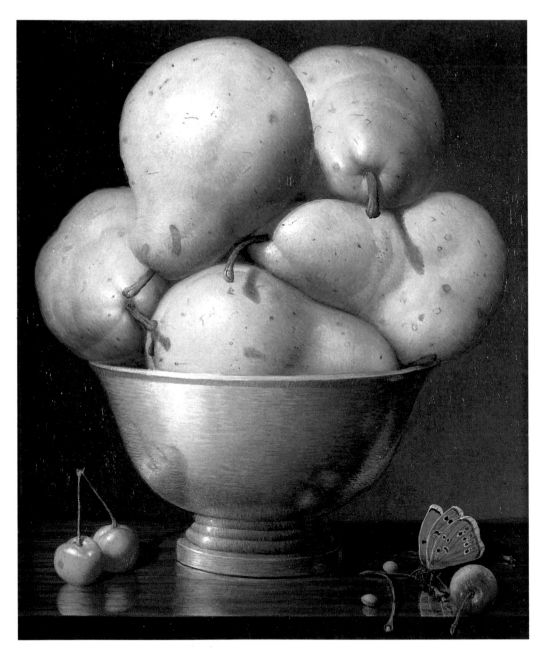

CHERRIES, PEARS AND BUTTERFLY
1989
Casein and oil on paper, 10½ x 8¾ in.
Collection Carl Spielvogel and Barbaralee Diamonstein-Spielvogel

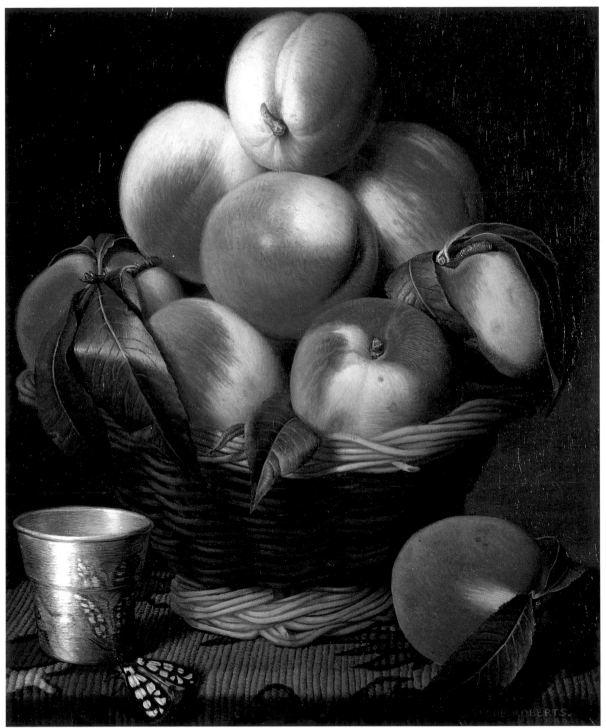

Peaches, Moth and Silver Jigger
1989
Casein and oil on paper, 10½ x 8¾ in.
Collection Carl Spielvogel and Barbaralee Diamonstein-Spielvogel

Study for *Venus and Adonis*
1987
Pencil on paper, 12 x 9½ in.
Collection Regina A. Trapp

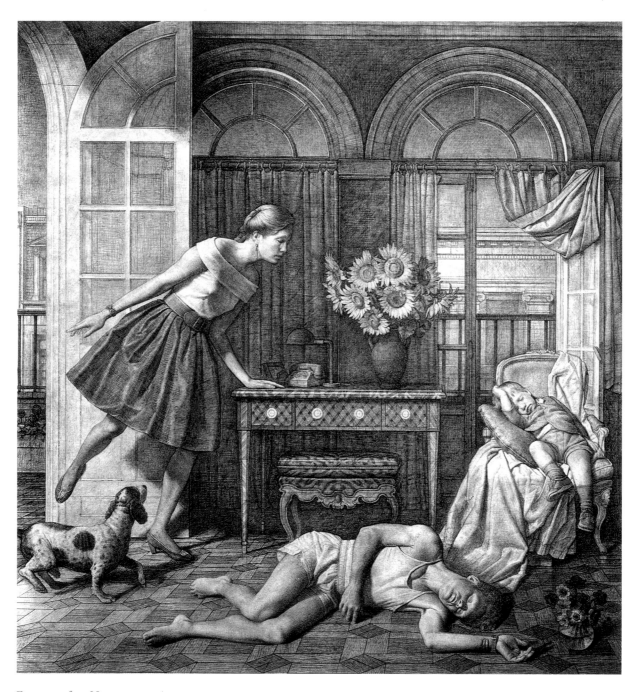

Cartoon for *Venus and Adonis*
1987
Pencil on paper, 16 x 20 in.
Private collection, New York

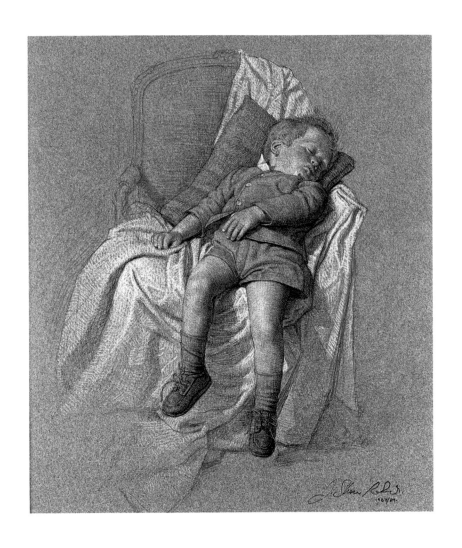

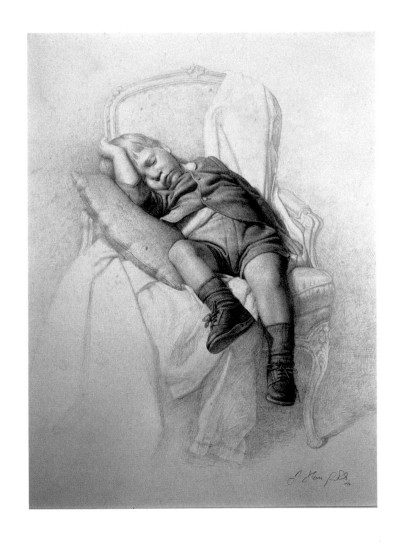

Study for VENUS AND ADONIS (DAVID)
1987/88
Pencil on paper, 14 x 10 ½ in.
Collection Carll and Diane Tucker

Study for VENUS AND ADONIS (DAVID)
1987/89
Pencil on tinted paper heightened with white, 11½ x 9¾ in.
Collection Stephens, Inc., Little Rock, Arkansas

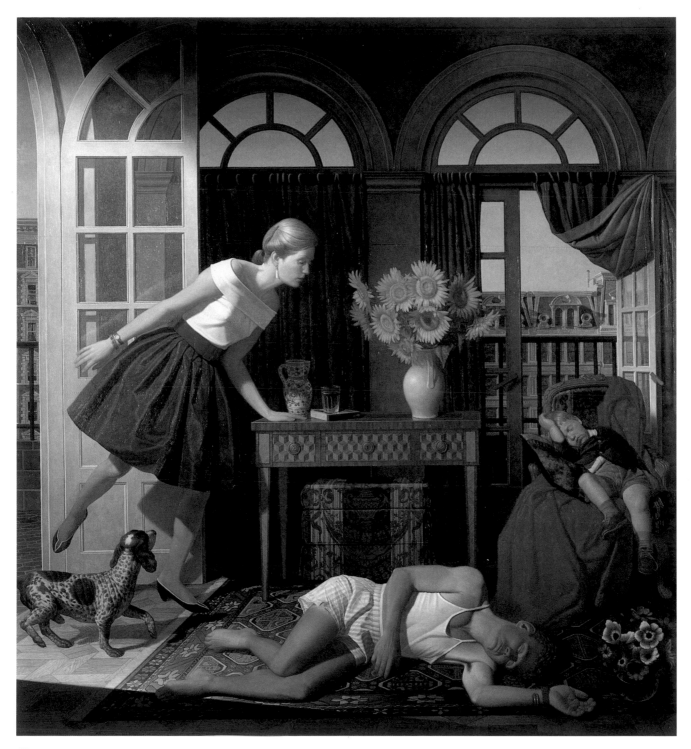

VENUS AND ADONIS
1987/88
Oil on canvas, 72 x 67½ in.
Private collection, Greenwich, Connecticut

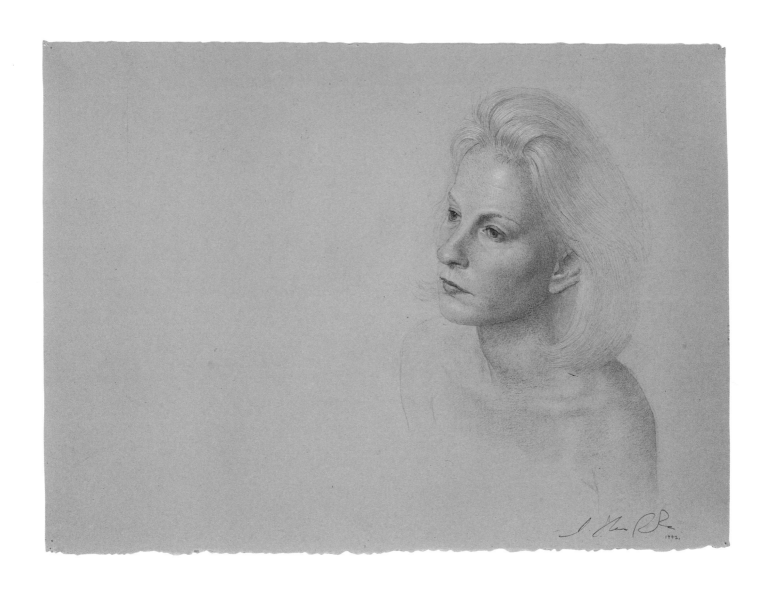

Study for *Paul and Caro*
1992
Colored pencils on tinted paper, 11⅛ x 15 in.
Private collection, London

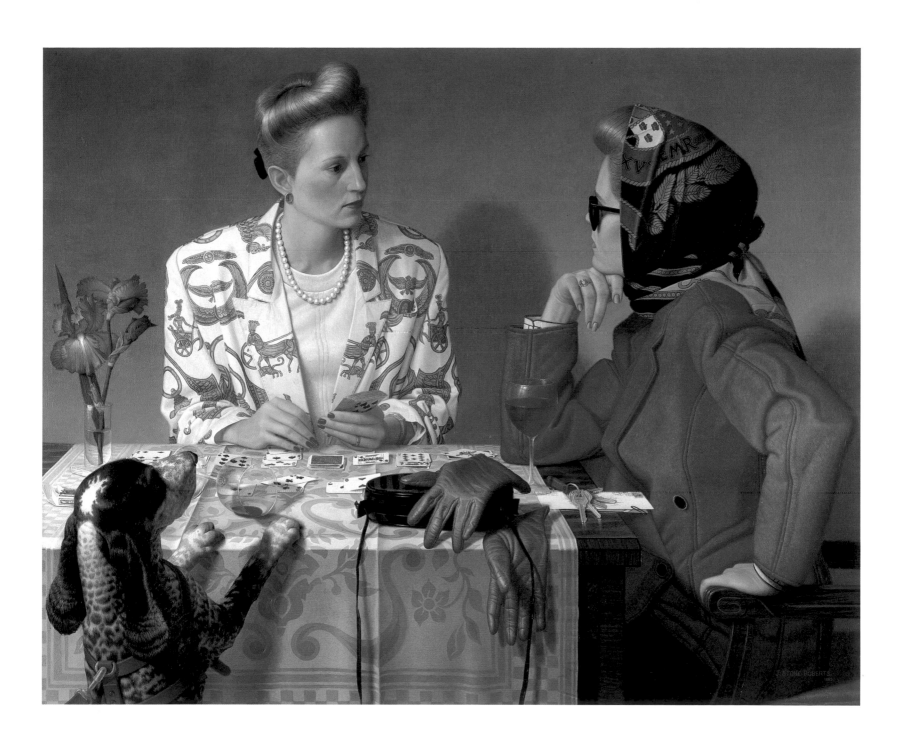

THE VISIT
1989
Oil on canvas, 37 x 45 in.
Collection Sydney and Walda Besthoff

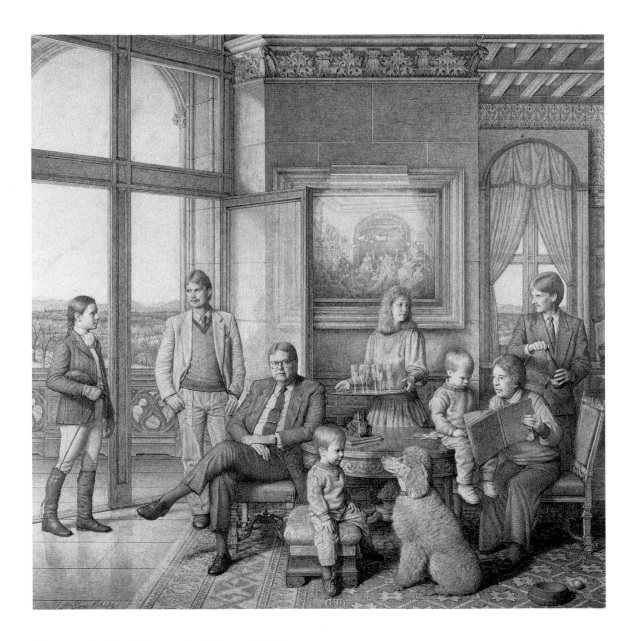

Cartoon for *THE WILLIAM A. V. CECIL FAMILY*
1990
Pencil on paper, 20¼ x 20¼ in.
Biltmore Estate, Asheville, North Carolina

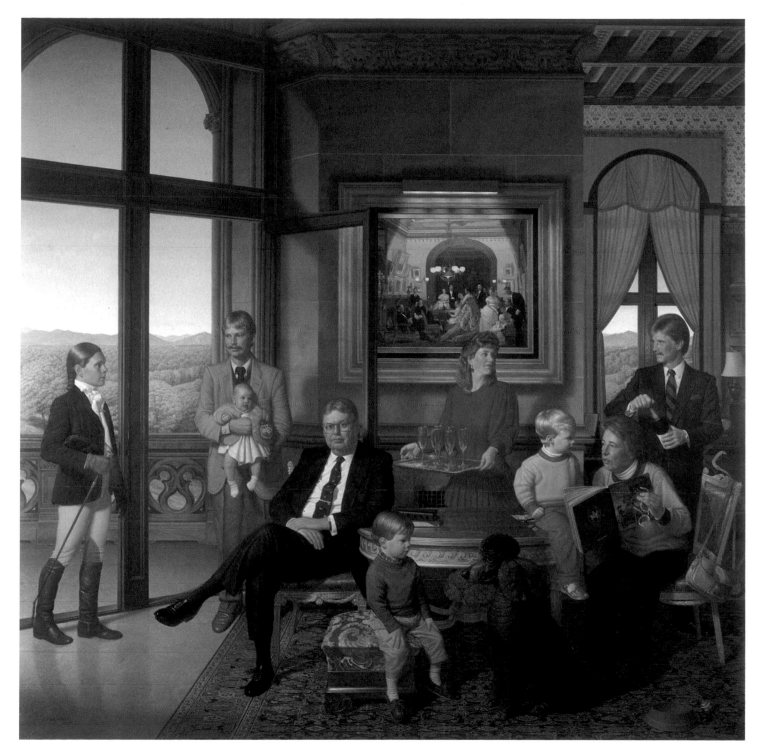

The William A. V. Cecil Family
1990/91
Oil on canvas, 81 x 81 in.
Biltmore Estate, Asheville, North Carolina

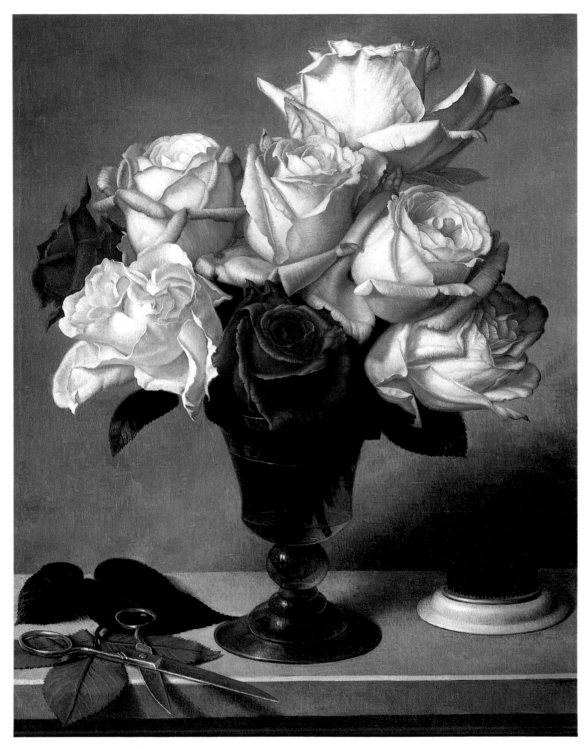

SCISSORS, FROG AND GARDEN ROSES
1991
Oil on canvas, 16 x 12½ in.
Collection Mr. and Mrs.
Richard L. Menschel

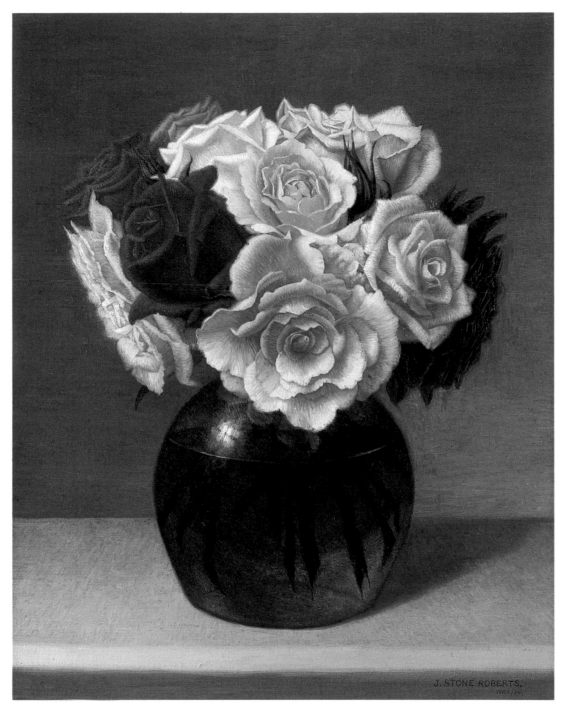

ROSES
1989/90
Oil on canvas, 15 x 12 in.
Private collection

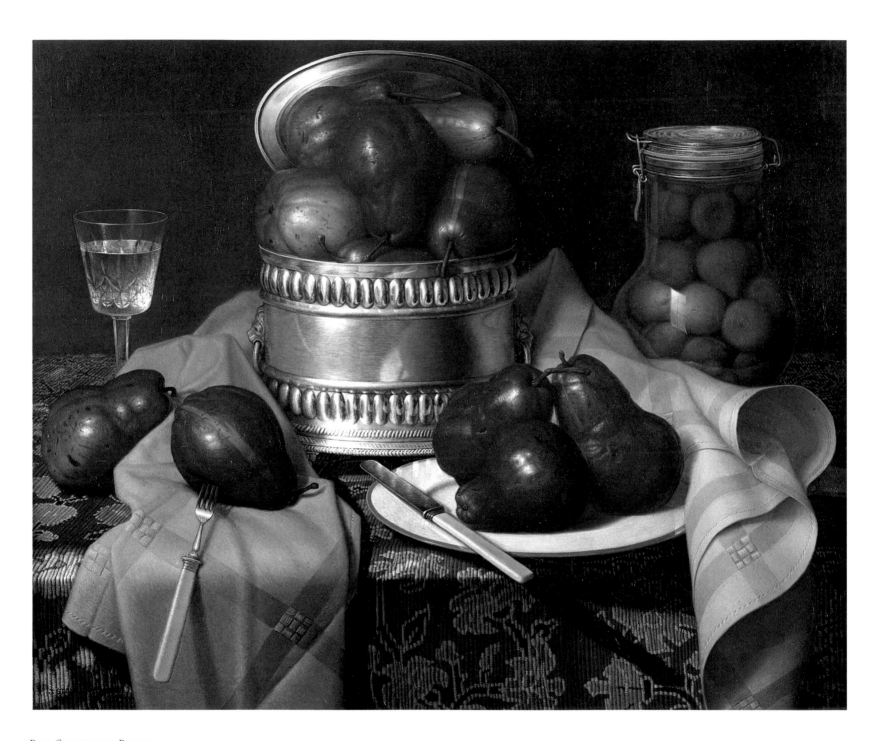

Red Sensation Pears
1989/90
Oil on canvas, 23⁵⁄₁₆ x 28⅛ in.
Collection Mr. and Mrs. Richard L. Menschel

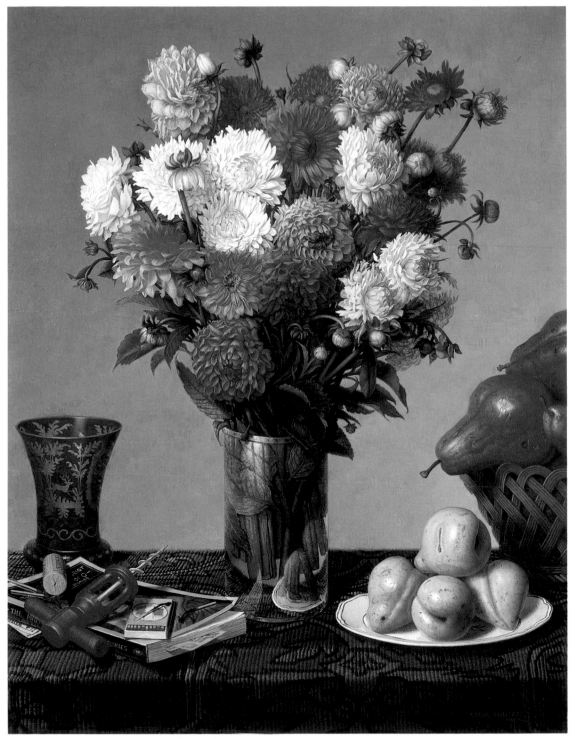

FRUIT, KLEIST AND DAHLIAS
1991/92
Oil on canvas, 25³/₁₆ x 19⁵/₈ in.
Collection Beatrix Maarsen Petter

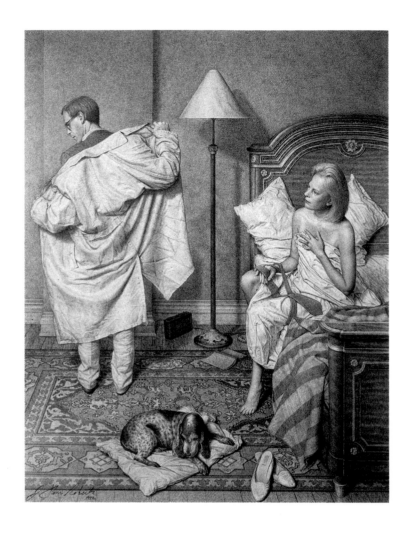

LUKE
1984
Pencil on paper, 8 x 10¼ in.
Private collection

Cartoon for *PAUL AND CARO*
1992
Pencil on paper, 16 x 12½ in.
Courtesy Salander-O'Reilly Galleries, Inc.

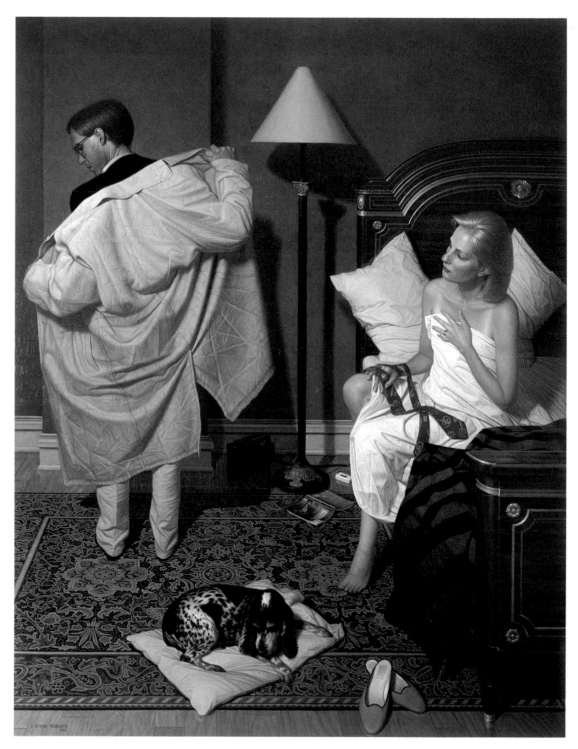

PAUL AND CARO
1992
Oil on canvas, 48 x 37½ in.
Collection Barbara Goldsmith

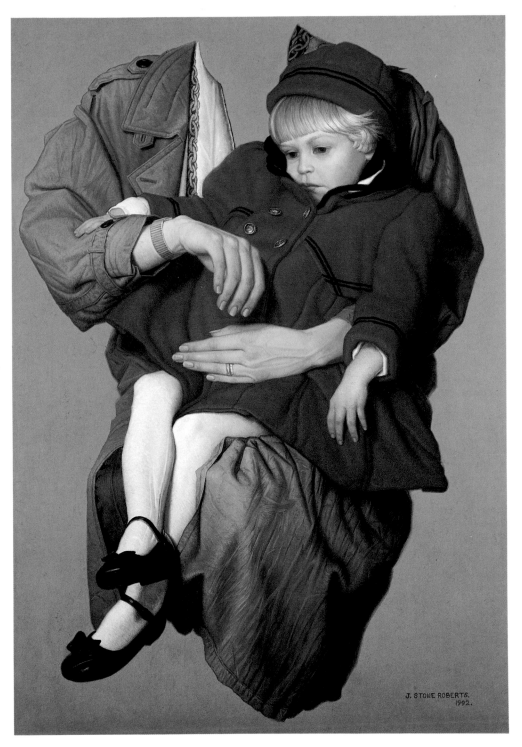

Study for REST ON THE FLIGHT INTO EGYPT
1992
Oil on canvas, 21⅜ x 15 in.
Private collection, North Carolina

60

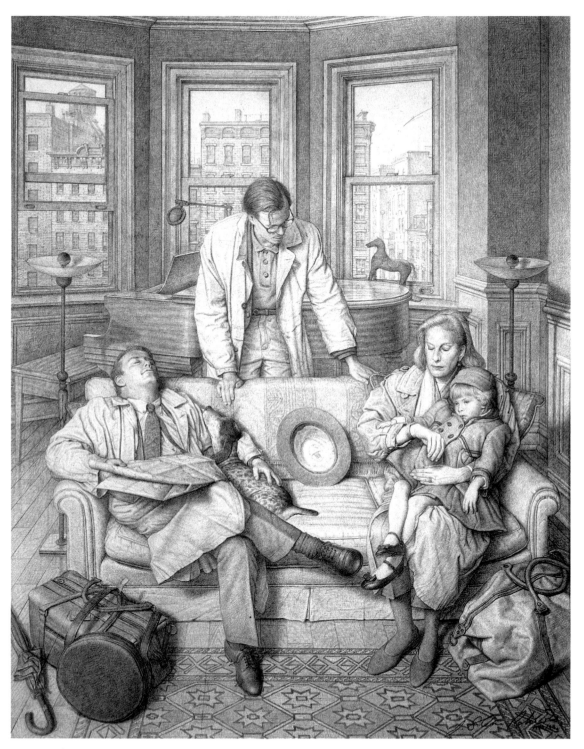

Cartoon for *Rest on the Flight into Egypt*
1992
Pencil on paper, 16 x 12½ in
Courtesy Salander-O'Reilly
Galleries, Inc.

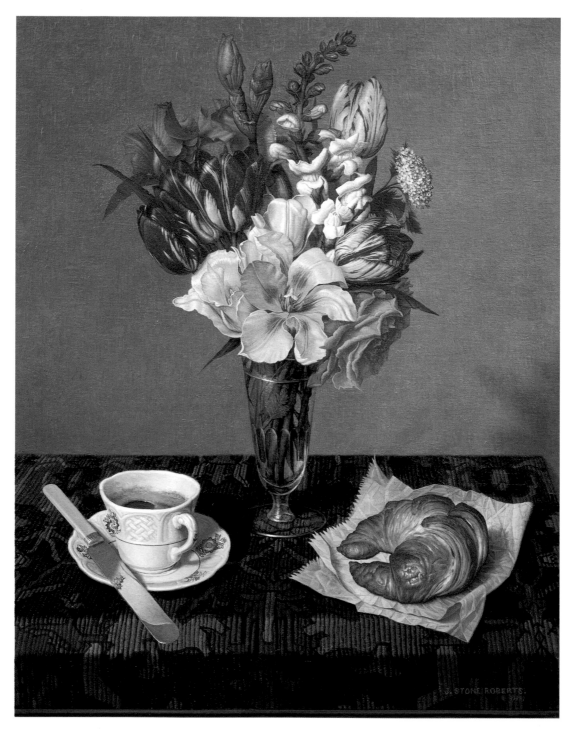

BREAKFAST STILL LIFE
1993
Oil on canvas, 20 x 16 in.
Private collection, Greenwich, Connecticut

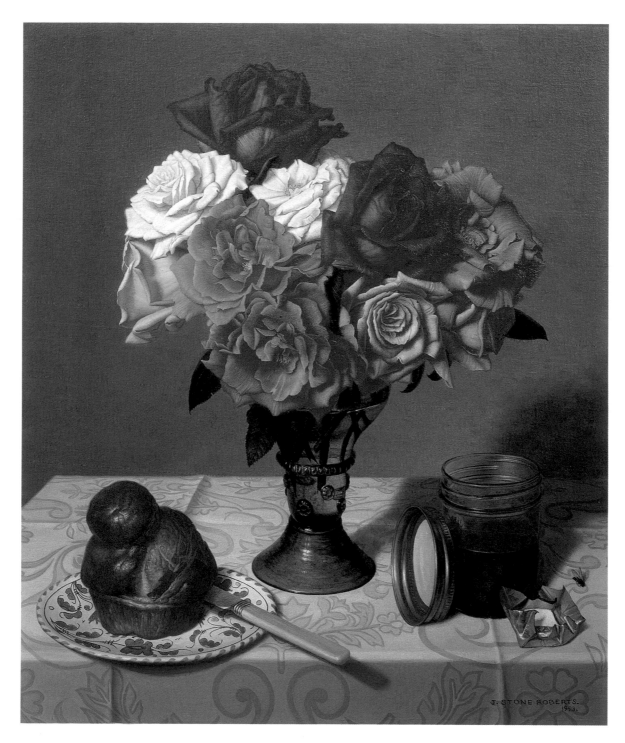

STILL LIFE WITH ROSES AND BRIOCHE
1993
Oil on canvas, 19 x 16¾ in.
Private collection, London

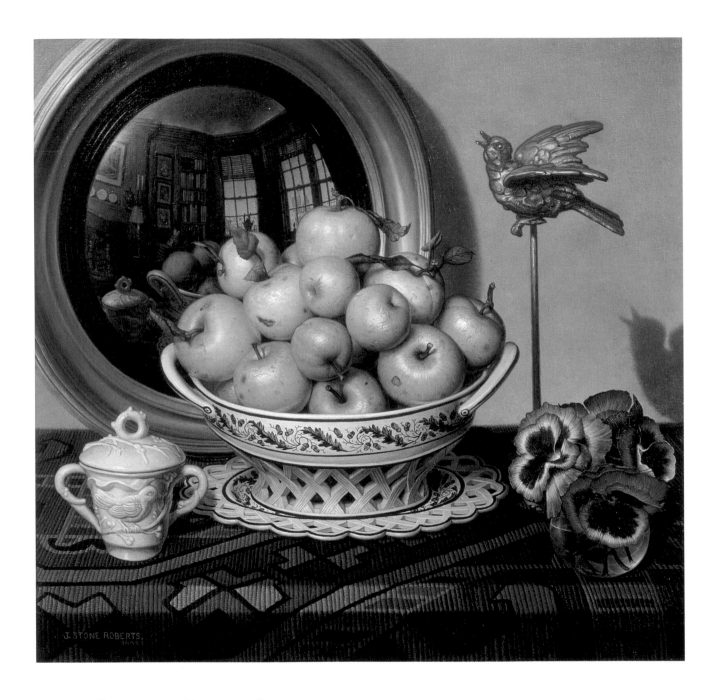

APPLES IN COMPOTE WITH MIRROR AND BIRDS
1992/93
Oil on paper, 17½ x 18⅜ in.
Collection Carl Spielvogel and Barbaralee Diamonstein-Spielvogel

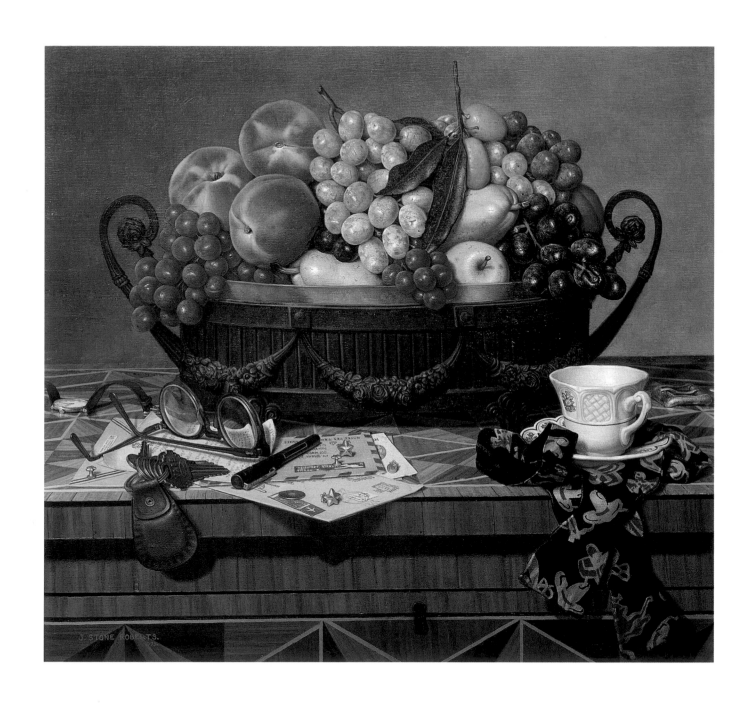

Dressing Table Still Life
1993
Oil on canvas, 17⁹/₁₆ x 18¹⁵/₁₆ in.
Private collection

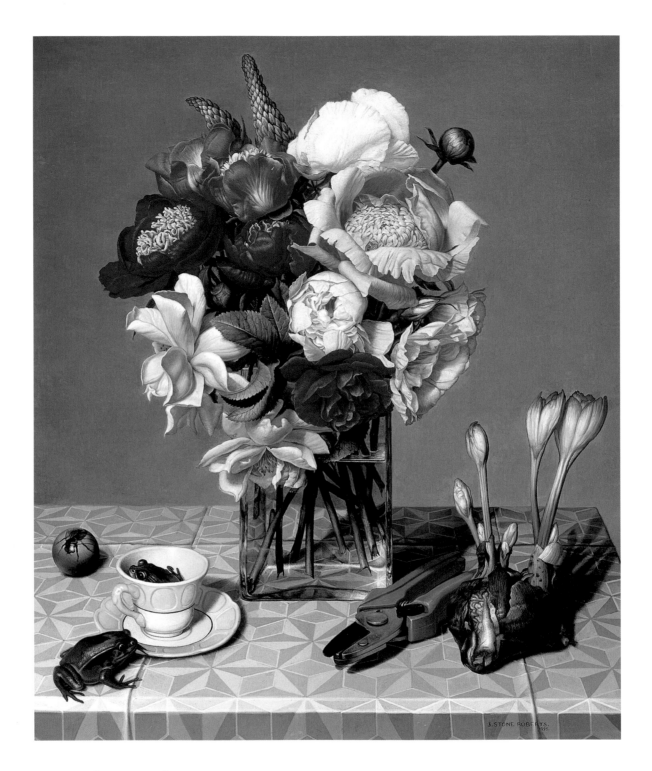

FLOWERS, FROGS AND COLCHICUM
1995
Oil on linen, 20¾ x 17¼ in.
Private collection, The Netherlands

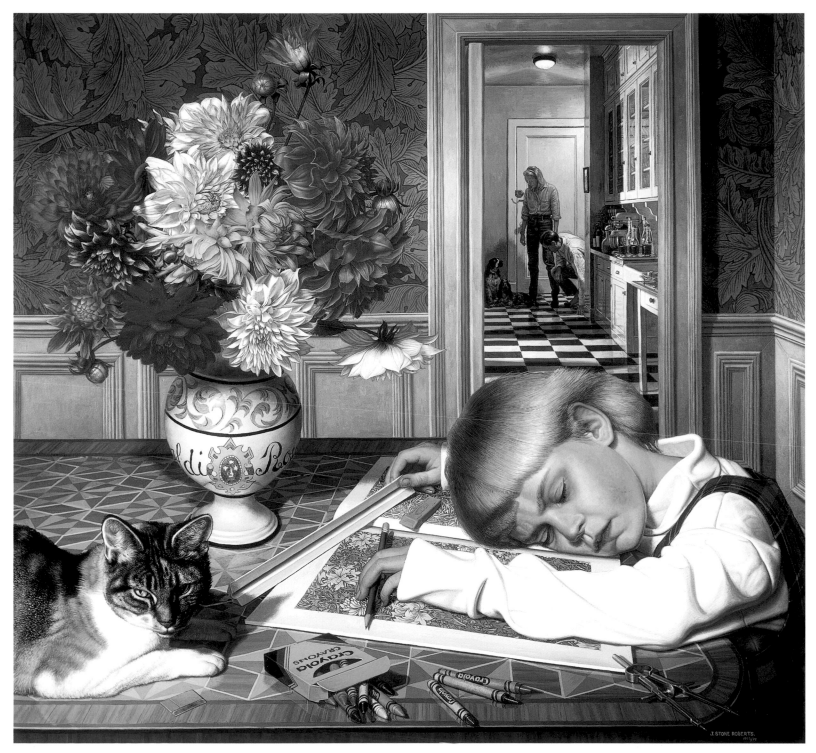

Child with Flowers
1996
Oil on canvas, 28 x 30 in.
Collection Seven Bridges Foundation,
Greenwich, Connecticut

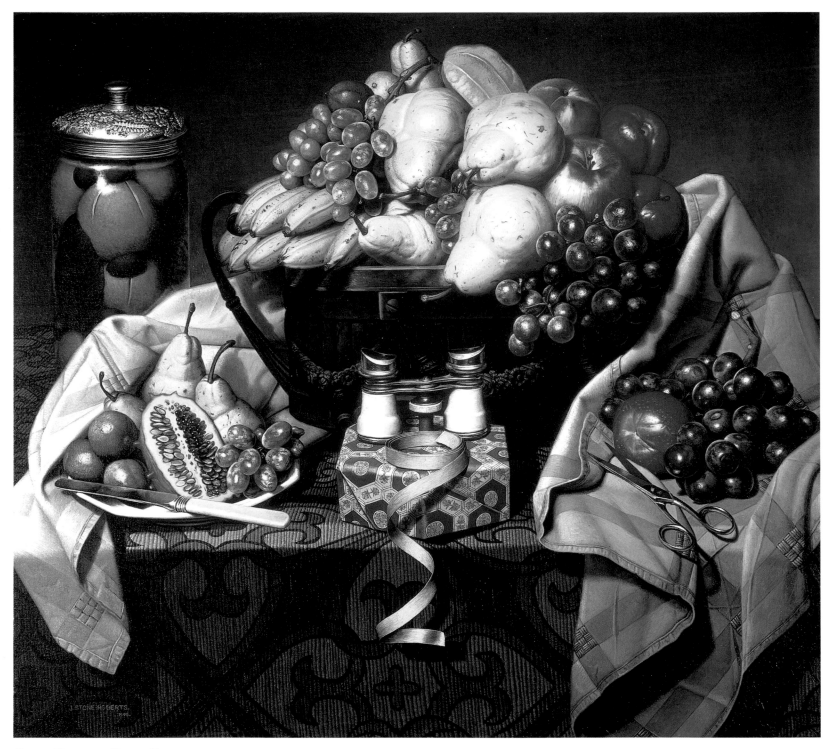

FRUIT, GIFT AND OPERA GLASSES
1995
Oil on linen, 24 x 27 in.
Private collection

Opposite:
PEONIES, ROSES, TULIPS AND CROCKERY
1995
Oil on linen, 24 x 27 in.
Private collection

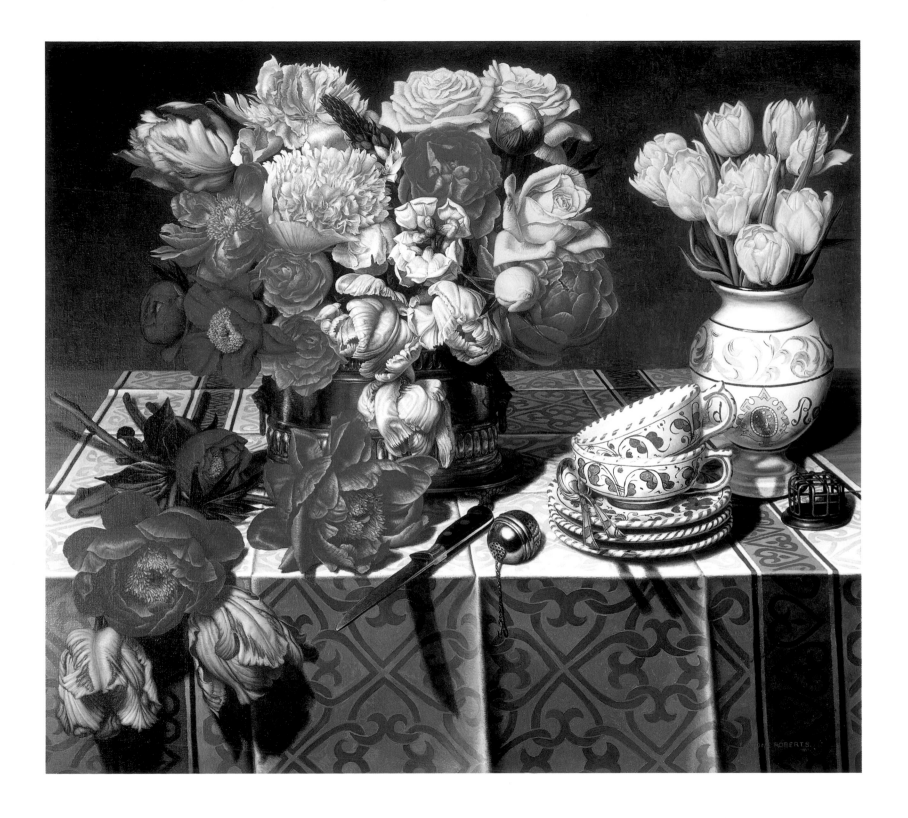

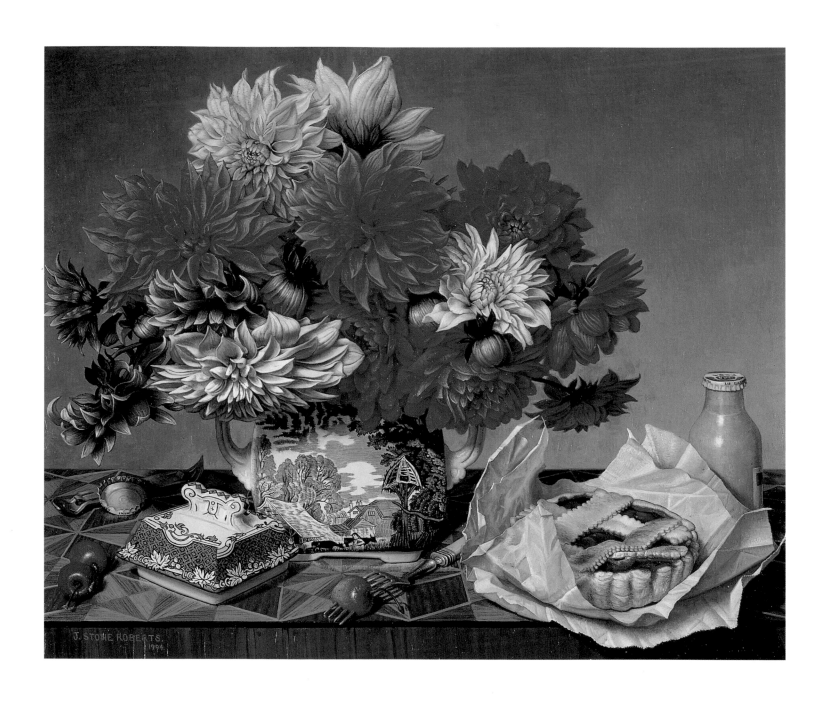

CHERRIES, TART AND DAHLIAS
1994
Oil on canvas, 14 x 17¼ in.
Collection T. A. and Carla Bewley

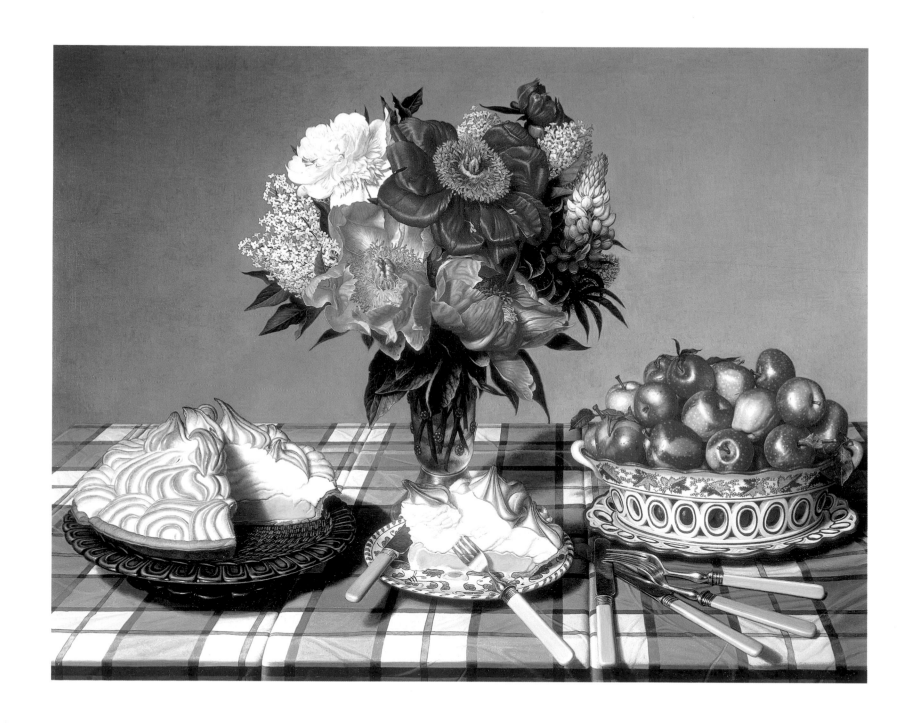

Peonies, Lilacs and Lemon Meringue Pie
1996
Oil on canvas, 28 x 30 in.
Private collection

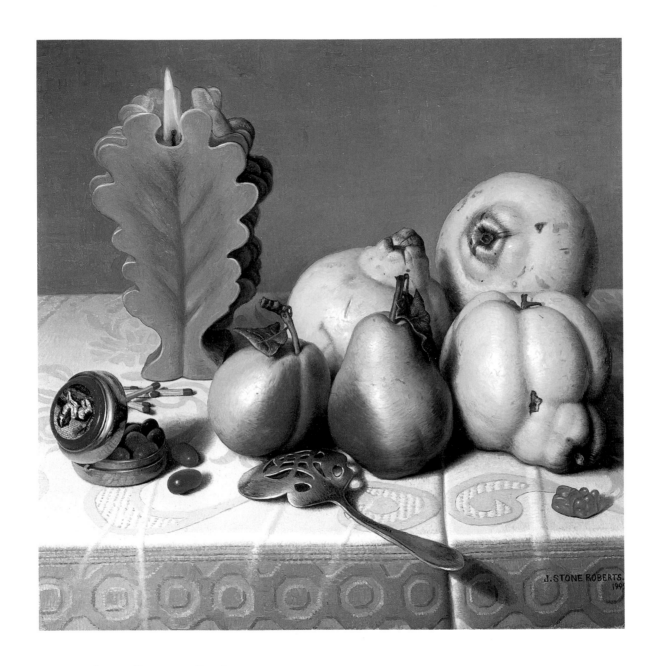

CANDLE, CANDY, FRUIT AND PILL BOX
1999
Oil on linen, 10 x 10 in.
Mr. and Mrs. Robert W. Cabaniss, Jr.

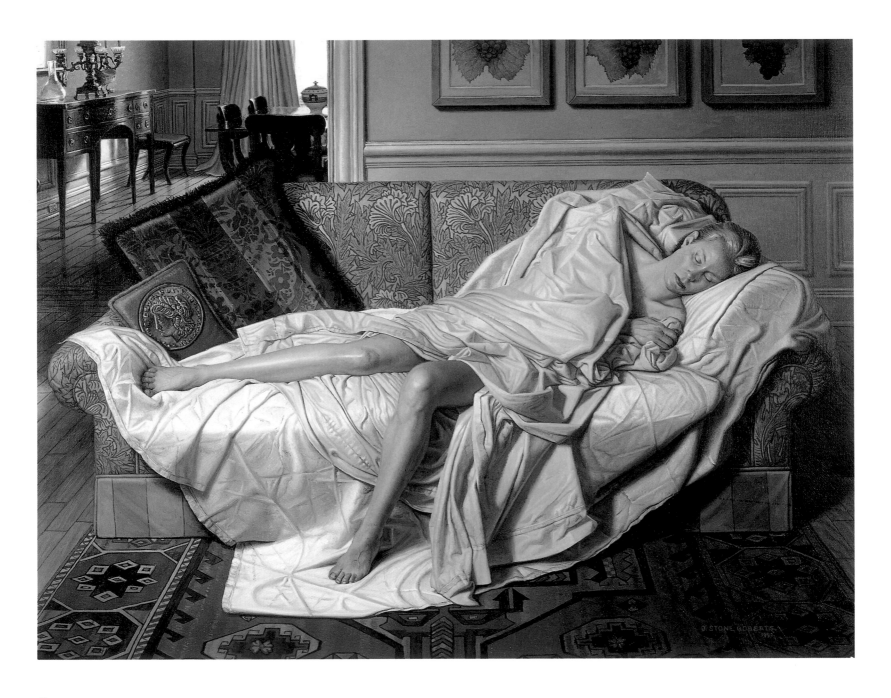

Danaë
1997
Oil on canvas, 12 x 16 in.
Collection Brooke and John Fowler

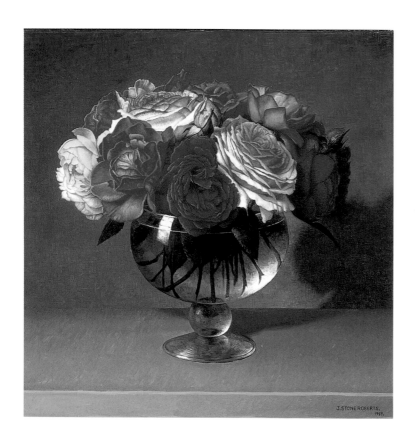

Garden Roses
1999
Oil on canvas, 12⅝ x 12 in.
Private collection

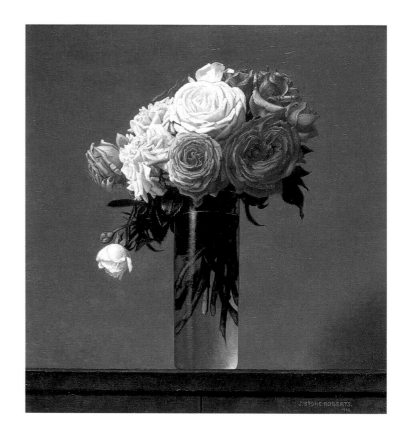

Roses in a Vase
1998/99
Oil on linen, 12⅞ x 11⅞ in.
Private collection, The Netherlands

Opposite:
Spring, Hillsdale
1997
Oil on canvas, 17¼ x 16 in.
Collection Brooke and John Fowler

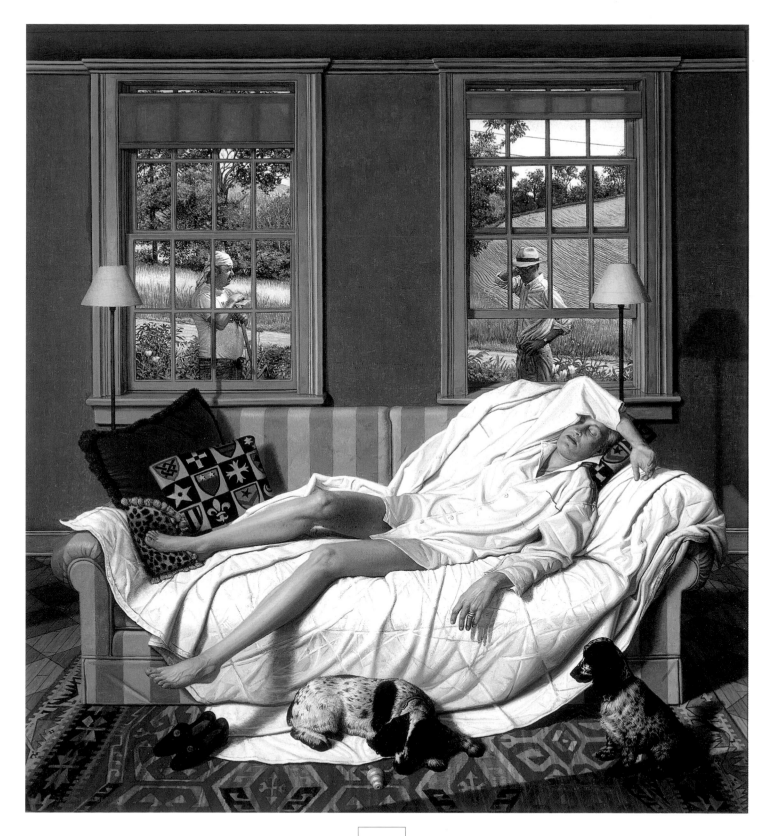

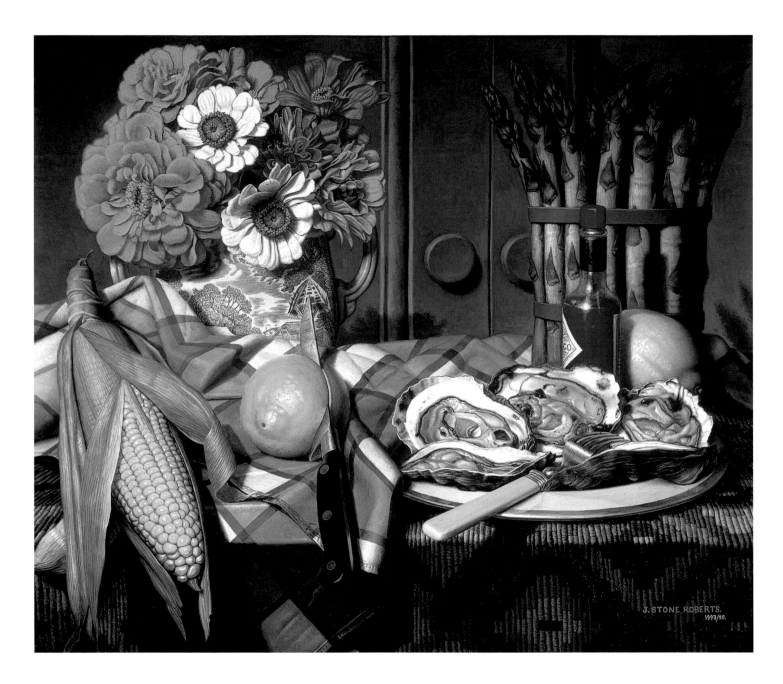

Zinnias, Asparagus, Oysters and Corn
1996/98
Oil on canvas, 14¾ x 17¼ in.
Collection Mr. Jerald Dillon Fessenden

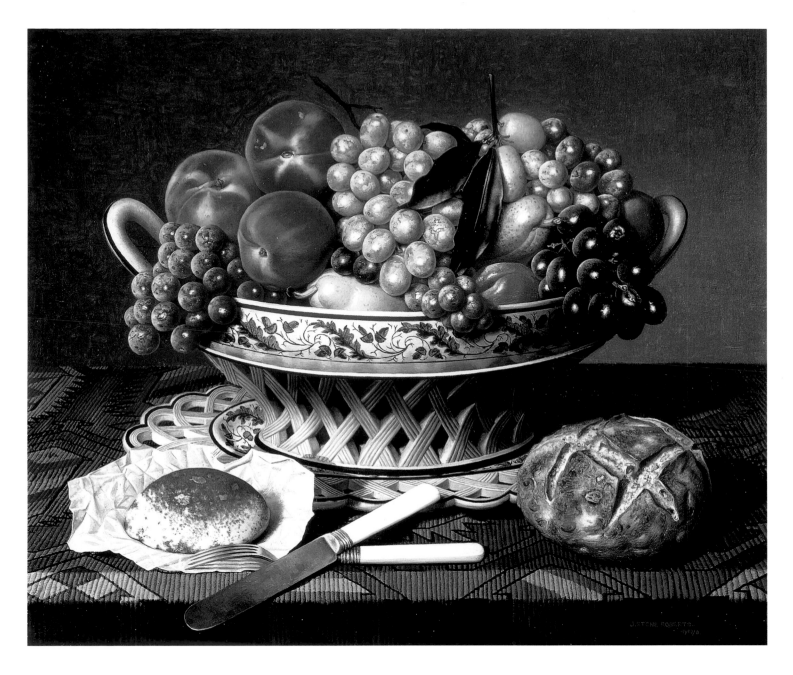

STILL LIFE WITH CHEVRE, FRUIT AND ROLL
1997/98
Oil on canvas, 13 x 15¼ in.
Private collection
Courtesy Hackett-Freedman Gallery, San Francisco

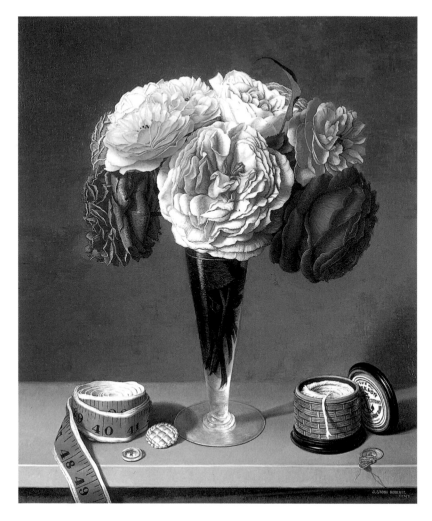

ROSES, TAPE MEASURE AND THREAD JAR
1999
Oil on linen, 17¼ x 14½ in.
Private collection
Courtesy Hackett-Freedman Gallery, San Francisco

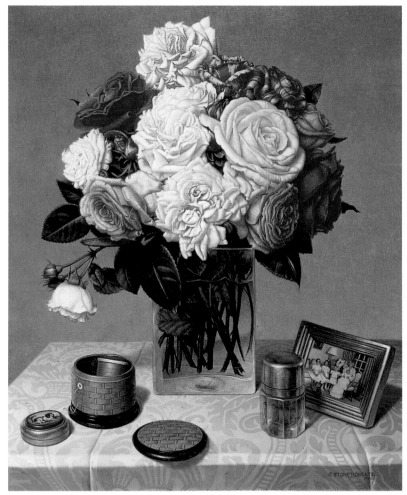

ROSES, THREAD, JAR AND FAMILY PHOTO
1994
Oil on canvas, 17 x 20 in.
Collection Mrs. Jack C. Massey

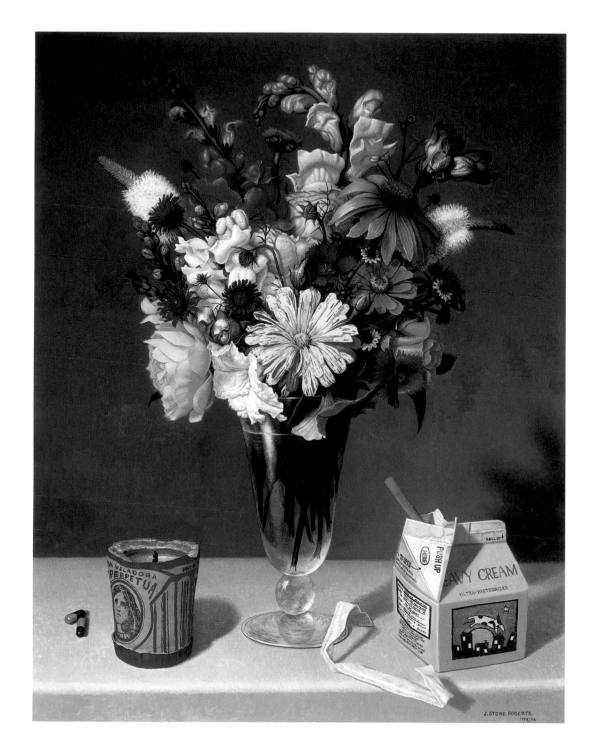

SUMMER FLOWERS WITH CANDLE, PILLS AND CREAM
1998/99
Oil on canvas, 16 x 12 in.
Collection Sydney and Walda Besthoff

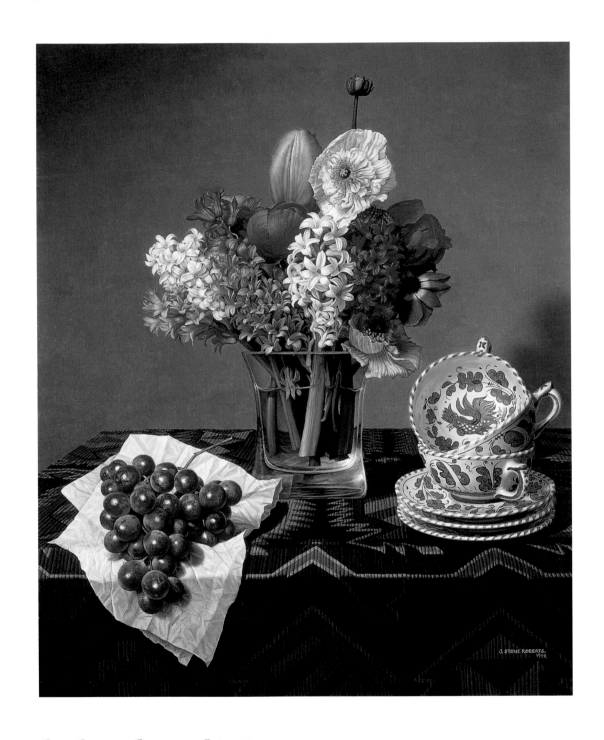

Cups, Saucers, Grapes and Flowers
1999
Oil on canvas, 24 x 20 in.
Collection Mr. and Mrs. Robert W. Cabaniss, Jr.

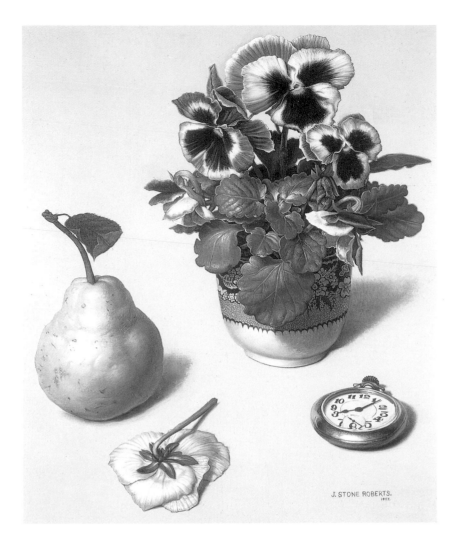

PANSIES, PEAR AND POCKET WATCH
1997
Oil on linen, 10¾ x 9¼ in.
Private collection

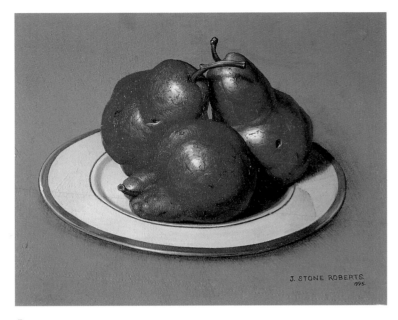

PEARS
1995
Oil on paper, 6¼ x 8 in.
Private collection

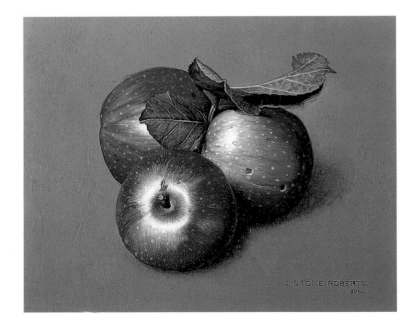

APPLES
1995
Oil on paper, 6¼ x 8 in.
Private collection

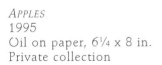

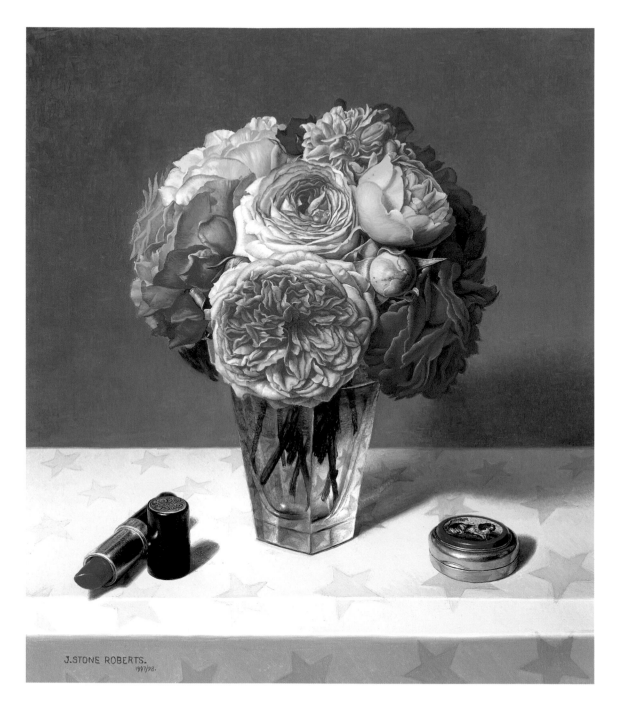

Lipstick, Pill Box and Garden Roses
1997/98
Oil on canvas, 12½ x 11 in.
Collection Brooke and John Fowler

Opposite:
Interior, Evening
1997/98
Oil on canvas, 75 x 60 in.
Private collection, Greenwich, Connecticut

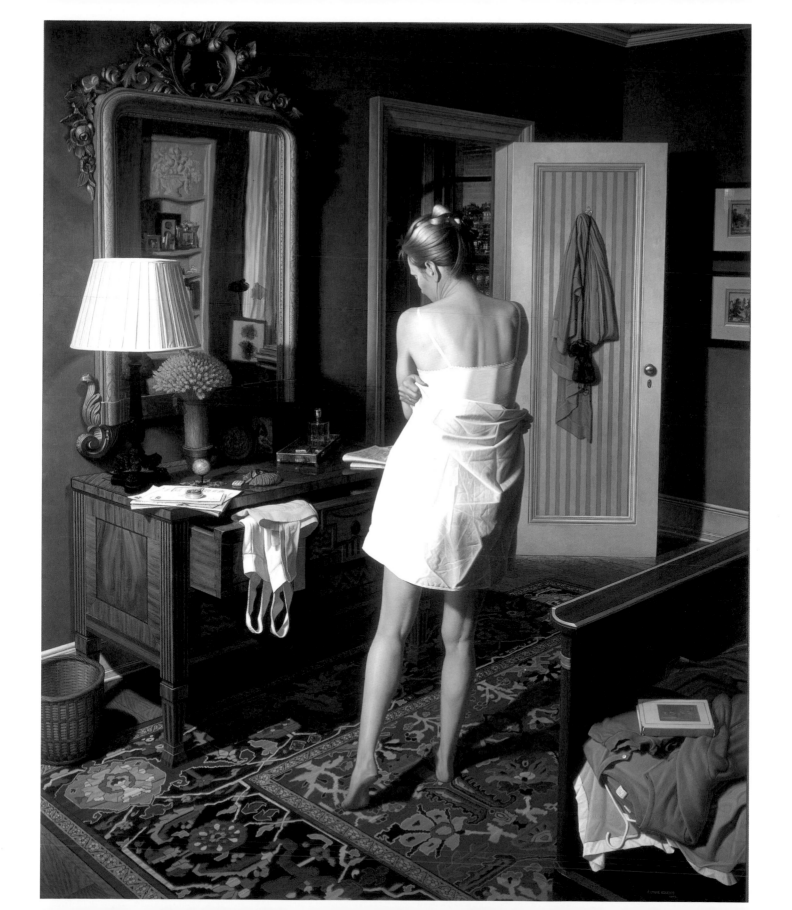

Study for *THE ELGART SIBLINGS, MAX*
2000
Oil on paper, 11 x 9½ in.
Collection Alice and David Elgart

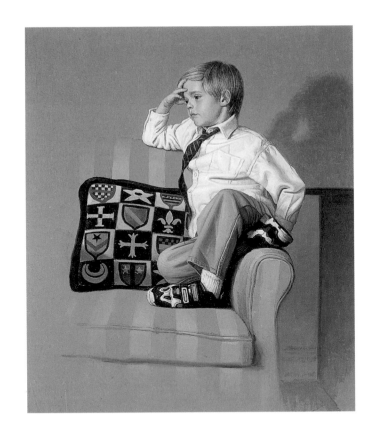

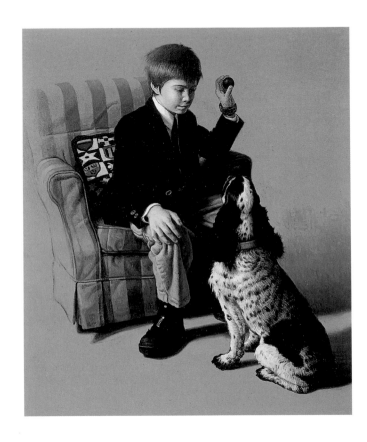

Study for *THE ELGART SIBLINGS, JACK*
2000
Oil on canvas, 11 x 9½ in.
Collection Alice and David Elgart

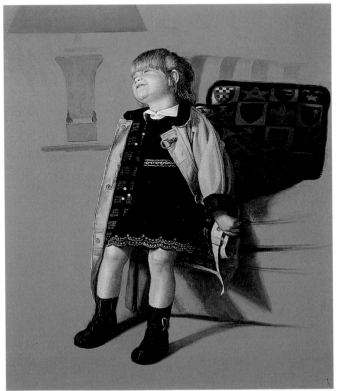

Study for *THE ELGART SIBLINGS, EVELYN*
2000
Oil on paper, 11 x 9½ in.
Collection Alice and David Elgart

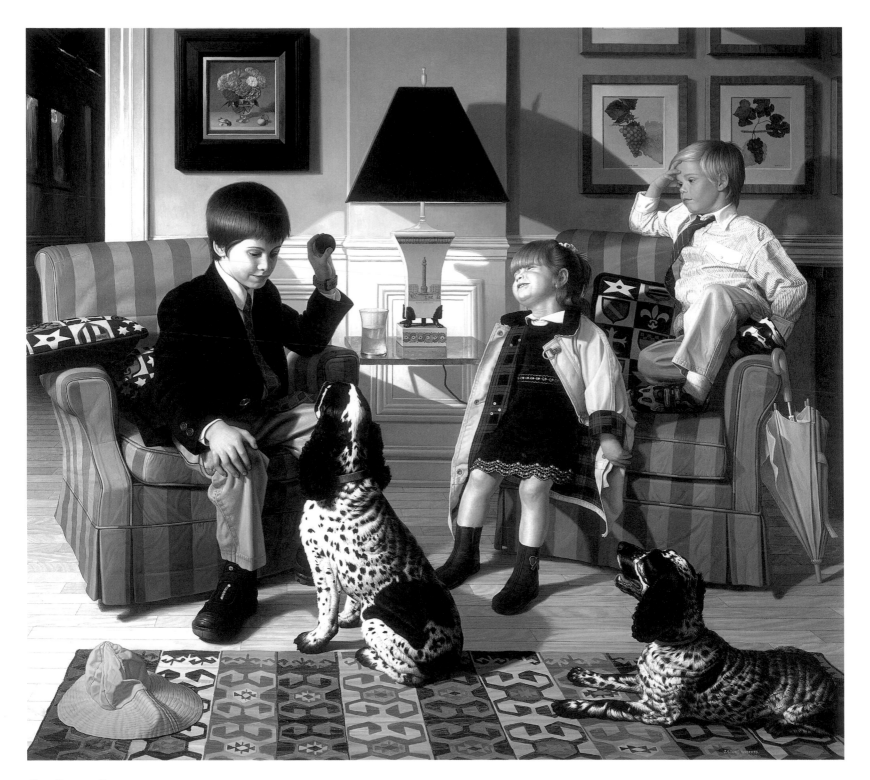

THE ELGART SIBLINGS
2000
Oil on canvas, 46 x 51 in.
Collection Alice and David Elgart

One~Man Exhibitions

1998
Stone Roberts: Recent Paintings, Salander-O'Reilly Galleries, New York

1993
Stone Roberts: Recent Paintings, Salander-O'Reilly Galleries, New York

1989
Centennial Exhibition, Walker Art Center, Woodberry Forest School, Woodberry Forest, Virginia

Recent Paintings, Robert Schoelkopf Gallery, New York

1986
Recent Paintings, Robert Schoelkopf Gallery, New York

Group Exhibitions

2000–1
Art in America: 2000, American Ambassador's Residence, Bratislava, Slovakia. Curated by Ash Fine Art, New York

1999
Self Images, Galerie Simonne Stern, New Orleans, Louisiana

Western North Carolina Collects, Asheville Art Museum, North Carolina. October 1999–January 2000

1998
Still Sixteen, Still Life, Galerie Simonne Stern, New Orleans, Louisiana

1996
Private Worlds: 200 Years of American Still-Life Painting, Aspen Art Museum, Colorado. December 19, 1996–April 6, 1997

1994
The Figure, Salander-O'Reilly Galleries, New York

Flowers, Babcock Galleries, New York

1991
American Narrative Painting and Sculpture: The 1980s (From the collection of The Metropolitan Museum of Art), Nassau County Museum of Art, Roslyn Harbor, New York

Contemporary Still-Life Painting, Coe Kerr Gallery, New York

Exquisite Paintings, Orlando Museum of Art, Florida

New Horizons in American Realism, The Flint Institute of Arts, Michigan

1988
A New Generation of the 1980s: American Painters and Sculptors, The Metropolitan Museum of Art, New York

Works on Paper, by Gallery Artists, Robert Schoelkopf Gallery, New York

1987
A Just Temper Between Propensities: New Still-Life and Landscape Paintings, Bayly Art Museum, University of Virginia, Charlottesville

1986
N.Y.C.: New York, Delaware Art Museum, Wilmington

1985
Contemporary American Still Life, One Penn Plaza, New York

1984
Recent American Still-Life Painting, Robert Schoelkopf Gallery, New York

Selected Bibliography

2000
Albee, Edward. *Art in America: 2000*. Exhibition catalogue. Bratislava, Slovakia

1999
Aston-Wash, Barbara. "Stories on Canvas. Beauty of Stone Roberts' work is in the details." *Knoxville News-Sentinel*, March 7.

Jones, Helena Z. "Artist Stone Roberts: A Look at his Work in the Context of his Life, in his Own Words." *The Greenville Sun*, March 17: C1, 2, 3.

Riva, Alessandro. "Stone Roberts." *Arte* (March): 126–31.

Waddington, Chris. "Paint is Real Subject of Still-Life Exhibit." *Times Picayune* (Lagniappe), July 10.

Wall, Donna Dorian. "Still Here After All These Years." *Southern Accents* (March–April): 112–16.

1998
Stevens, Mark. "Art Transplants." *New York* (November 30): 127–28.

Thomas, Michael M. "Painter Stone Roberts—By George, He's Got It!" *The New York Observer* (November 9): 1, 15.

Tucker, Carll. Exhibition catalogue. New York: Salander-O'Reilly Galleries.

———. "Stone Roberts." *The Patent Trader* (November 13): 1–2.

1997
Brown, Tricia. "Stone Roberts." *The Artful Mind* (April): 16–17.

1996
"Private Worlds: 200 Years of American Still-Life Painting." Exhibition catalogue. Aspen, Colo.: Aspen Art Museum.

Riva, Alessandro. "Stone Roberts, una scoperta: L'Americano che dipingere Romanzi." *Arte* (April): 86–95.

1994
Biddle, Cordelia Francis. "Family Portraits." *Town and Country* (July): 20.

Cooper, James F. "The Courage to Paint." *American Arts Quarterly* (Winter): 17–18.

Hurwitz, Laurie S. "Cover Artist: Stone Roberts." *American Artist* (April): 68–71.

Huygens, Stan. "Een vriend van de Guillermo's." *De Telegraf* (Amsterdam), May 13.

1993
Guillermo, Jorge. "The Ambiguous World of Stone Roberts." *Tableau Magazine* 16, no. 2 (November): 36–41.

Jones, Helena Z. "A New Book Features Stone Roberts at His Exhibit." *The Greenville Sun*, November 3.

Tanaka, Yoko. "Stone Roberts." *Seven Seas* (Tokyo) (January): 86–87.

———. "Stone Roberts: Paintings and Drawings." *Art Times* 10, no. 4 (November): 18.

1992
Brenner, Douglas. "Scenes From Everyday Life." *House & Garden* (April): 82–84.

Grimes, Nancy. "Contemporary Still-Life Painting." *ARTnews* (March): 131.

Jones, Helena Z. "Lemons, Lilies and Gourds." *The Greenville Sun*, February 26.

1991
Henry, Gerrit. "Exquisite Paintings: A Paradigm for the Twenty-first Century?" In *Exquisite Paintings*, exhibition catalogue. Orlando, Fla.: Orlando Museum of Art.

Lieberman, William S. *American Narrative Painting and Sculpture: The 1980s*. Exhibition catalogue. Roslyn Harbor, N.Y.: Nassau County Museum of Art.

Young, Christopher R. *New Horizons in American Realism*. Exhibition catalogue. Flint, Mich.: The Flint Institute of Art.

1989
Brenson, Michael. "Stone Roberts." *The New York Times*, November 3.

Talbot, Charles. *Stone Roberts: Recent Paintings*. Exhibition catalogue. Woodberry Forest, Va.: Walker Art Center.

1988
A New Generation of the 1980s: American Painters and Sculptors. New York: The Metropolitan Museum of Art.

1987
Cooper, James F. "An Interview with Stone Roberts." *American Arts Quarterly* (Spring/Summer): 6–8.

———. "Stone Roberts: A Young Realist Finds Himself Through His Art." *New York City Tribune*, October 9.

Jencks, Charles. *Post Modernism*. New York: Rizzoli International Publications.

1986
Cooper, James F. "Stone Roberts' Still Lifes Embody Beauty and Values." *New York City Tribune*, September 12.

Doherty, Stephen M. "A Survey of Contemporary Still Lifes." *American Artist* (February): 45.

Jencks, Charles. *What is Post-Modernism?* London and New York: Academy Editions and St. Martin's Press.

N.Y.C.: New Work. Exhibition catalogue. Wilmington: Delaware Art Museum.

Raynor, Vivian. "Stone Roberts." *The New York Times*, September 12.

1985
Henry, Gerrit. *Contemporary American Still Life*. Exhibition catalogue. New York: One Penn Plaza.

Photograph Credits

Numbers refer to pages.

eeva inkeri: 10, 18–23, 31–37, 39, 41, 42, 49; The Metropolitan Museum of Art: 25; Photography, Inc.: 29; Adam Reich: 43–45, 51, 53, 55, 56; Christopher Burke: 5, 54, 57, 60; Salander O'Reilly Galleries, Inc.: 24, 26–28, 30, 38, 40, 46–48, 50, 52, 58, 59, 61–65, 70, 78; Paul Waldman: jacket front, jacket back, 1, 2, 6, 66–69, 71–85